LEGENDARY

— OF —

ANDERSON ISLAND

WASHINGTON

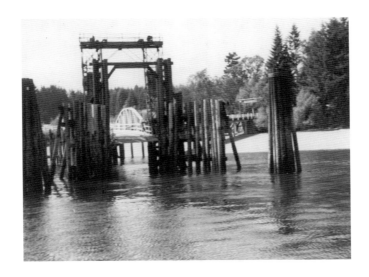

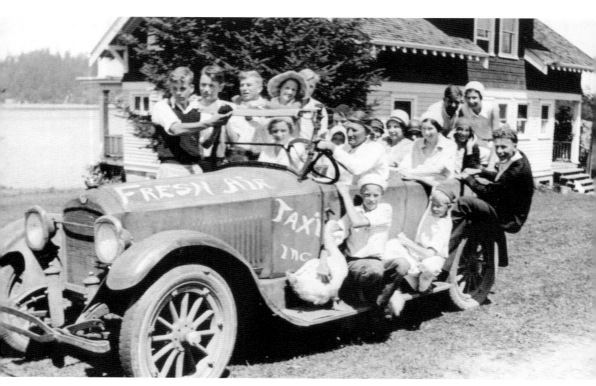

The Fresh Air Taxi
Here, three generations of the Bengt Johnson family and friends enjoy the Fourth of July in 1931. From left to right are (on near running board) Roger Cammon and Russ Cammon with Icabod (goose) and Jack (dog); (front seat) Florence Semon and Oscar Cammon; (middle seat) Elinor Macintyre with her baby Eva Baggs, and Dorothy Macintyre; (rear seat) Anna Johnson, Mrs. Macintyre, and Bessie Cammon; (on rear) Ben Johnson and Betty Schmidt; (on fender) Larry Semon; (far running board) Robert Macintyre, Jack Brown, Gunnard Johnson, Ruth Swanberg, and Robert Cammon. (Courtesy of Anderson Island Historical Society.)

Page I: Welcome to Anderson Island
The island's front door is the ferry landing on the northeast side. (Courtesy of Anderson Island Historical Society.)

LEGENDARY LOCALS

OF

ANDERSON ISLAND

WASHINGTON

LUCY STEPHENSON, MICHAL SLEIGHT,
AND RICK ANDERSON

**LEGENDARY
LOCALS**

Legendary Locals is an imprint of Arcadia Publishing
Charleston, South Carolina

Printed in the United States of America

Library of Congress Control Number: 2013955461

For all general information, please contact Arcadia Publishing:
Telephone 843-853-2070
Fax 843-853-0044
E-mail sales@arcadiapublishing.com
For customer service and orders:
Toll-Free 1-888-313-2665

Visit us on the Internet at www.arcadiapublishing.com

Dedication
For our fellow islanders, past, present, and future, whether named or unnamed in the pages to follow. May our island always be blessed!

On the Front Cover: Clockwise from top left:
Bob Ehricke, builder (courtesy of Cindy Ehricke Haugen; see page 68), Lois Scholl, historical society founder, and Hazel Heckman, author (courtesy of Anderson Island Historical Society; see pages 32, 33), Rudy Johnson, Ruth Johnson Laing, Oscar Johnson, and Al Laing, Johnson Dairy and Egg Farm (courtesy of Anderson Island Historical Society; see page 27), Lowell Johnson, builder (courtesy of Cindy Ehricke Haugen; see page 69), William Ekenstam, photographer (courtesy of Dianne Avey; see page 88), Lyle Carlson, storekeeper (courtesy of Anderson Island Historical Society; see page 113); Ralph Christensen, part of team that established historical society (courtesy of Terry Bibby, see page 36), Christine Anderson, farmer (courtesy of Terry Bibby; see page 30), Oscar Cammon and Bessie Johnson Cammon, historian and writer (courtesy of Anderson Island Historical Society, see page 31).

On the Back Cover: From left to right:
Matt Iverson and Erik Halverson, sailors (courtesy of Anderson Island Historical Society; see page 126.), Rudy and Ruth Johnson (courtesy of Anderson Island Historical Society; see page 27).

CONTENTS

ACKNOWLEDGMENTS

The authors acknowledge their profound debt to Bessie Cammon and Hazel Heckman, without whose foundational *Island Memoir* and *Island in the Sound*, production of this book would have been literally impossible. Liz Galentine's book in the Images of America series, *Anderson Island*, has also been helpful in directing the course of the present work. This book in no way replaces these three works, but hopefully contributes a fresh, up-to-date perspective on the ongoing history and culture of its subject community.

No one could ask for more support and understanding than we received from our editor, Erin Vosgien at Arcadia Publishing. She has provided guidance throughout the process, and many thanks are due her and the Arcadia team. The Anderson Island Historical Society has been generous with its extensive collection of images and documents, the availability of which has proven absolutely essential. Special appreciation is extended to the many families represented herein who have likewise cheerfully collaborated in the project by providing images and information. Cindy Haugen, Terry Bibby, Dianne Avey, Candyce Anderson, Andy Hundis, Marilyn Brown, and Donna Baskett Gabriel have been particularly heroic in their support. Dr. Evans Paschal's assistance with processing the images was simply monumental.

The authors have been privileged to consult with noted experts whose special knowledge of the region has significantly improved the book's accuracy. Drs. Nile Thompson and Brian Magnusson, Jean Cammon Findlay, and Richard Blumenthal are the first to come to mind, but there are numerous others who are to be thanked even if their names do not appear here. It is hoped that the reader will not hold them responsible for any errors that have escaped their notice; for those, the authors accept sole responsibility.

Even should the authors wish to break new ground by neglecting the customary expression of gratitude to their long-suffering spouses, they could not in good conscience do so, for Ed Stephenson, Terry Sleight, and Melissa Anderson have been simply amazing in their steadfast support and forbearance throughout. It can only be hoped that they will find their rewards in satisfaction with the final result. Finally, the authors mutually salute and thank each other for the wonderful camaraderie and exhilaration of bringing this book to completion.

INTRODUCTION

Anderson Island, the southernmost of all islands in Puget Sound, is situated in Pierce County, Washington, about eight miles southwest of the Tacoma Narrows. It is surrounded on all sides by one to three miles of saltwater, except on the north, where neighboring McNeil Island approaches it to within 1,200 yards. The island, approximately five miles long and three miles wide at its extremities, comprises over 5,000 acres of uplands and includes two large lakes, Florence and Josephine, besides a number of ponds. The island's roughly 25 miles of shoreline are indented by numerous bays and pocket estuaries. Here and there, small creeks make their way to the saltwater of the sound.

Native tribes occupied temporary homes on the island from time immemorial, digging clams and shooting sea fowl from the beaches, hunting deer in the uplands, and felling trees to be used for planks and canoes. Attempts by immigrants to settle the island in the 1840s and 1850s proved futile, and it was not until the influx of maritime-seasoned Scandinavians in the early 1870s that the first permanent residents set down roots.

The earliest settlers naturally busied themselves with logging the island's magnificent stands of timber to prepare the ground for their farms. They found a ready outlet for the fruit of their labors in the cordwood-burning steamers that plied Puget Sound and regularly put in at several small landings, which furnished fuel and fresh water to the fleet. Once cleared, the lean glacial till and clay soils of the island, while not deep and luxurious like those of the nearby river valleys and deltas, were at least adequate to support small dairy herds and flocks of poultry. The thrifty and industrious immigrants found markets for their products in nearby cities. Shipping by water gave them at least a level playing field in the competition with other farmers in the areas outlying Seattle, Tacoma, and Olympia. Some, having spent their younger days on the islands and fjords of the Nordic countries, resorted to fishing and shrimping to serve the same markets. With the advent of the automobile, improved roads, and electrification on the mainland, the tables turned to favor those who could access the urban markets by truck and power their operations with more modern equipment. Regular ferry service came to Anderson Island only in 1922, and public power did not arrive until 1961.

Still, a handful of second-generation islanders doggedly kept to their parents' homesteads and managed to support their families at least through the Depression and the early postwar years. Their names read like the passenger list of a shipload of immigrants from Denmark, Sweden, or Norway—Johnson, Petterson, Andersen, Engvall—with a Swiss or German tossed in here and there. The island developed its own unique community, seldom exceeding 100 persons, never dropping much below that. Hand-cranked telephones, introduced in 1917, connected the scattered farms and cottages until 1962. A one-room schoolhouse met the needs of the island's children until its closure in 1968. A community clubhouse, the modern version built in 1928, serves as a social and cultural center of the island to this day.

With the advent of electricity via submarine cable, the island became more attractive to developers and to vacationers seeking refuge from the mainland. The population rose steadily in the 1970s, 1980s, and 1990s, fueled by improvements in the infrastructure including paved roads and increased ferry service. By 2010, the island's population had reached 1,000, though in winter it scarcely tops 800. Retired persons constitute a substantial majority of today's islanders, many of whom are "snow birds." Despite, or perhaps because of, the relative isolation—the island is reached only by private boat and Pierce County Ferry from Steilacoom—a hardy and largely self-sufficient community is found there. The resulting island culture, subtle and yet quirky, is passionately nurtured and defended by both the descendants of the pioneers and latecomers who have chosen to make the island their home.

Most of the island's virgin old-growth covering of giant fir, cedar, and hemlock trees has been logged over and replaced by second- or third-growth timber, augmented by alder, madrona, and big-leaf maples. Occasionally, this pattern is broken by pasture, often overrun by blackberries, abandoned orchards, and wetlands vegetation. The island is dotted with small farms of 20 to 100 acres, mostly neglected. Fewer than 30 head of cattle and a few dozen chickens share the island with a small herd of rather tame deer, raccoons, and, a recent addition, coyotes. A mild sensation was caused lately by the appearance of a black bear, which has been spotted both arriving and leaving by water. Along the beaches is found a mixture of permanent homes and summer cottages. In the center of the island, 1,100 acres have been divided into small lots, upon which approximately 700 homes and cabins have been built.

The future of Anderson Island, though uncertain, will evidently be determined by, among other things, the cost and degree of convenience of ferry service, the availability of fresh water, and access to electric power. Suffice it to say, though, that virtually every resident will readily swear that if they ever move off the island, it will only be feet first.

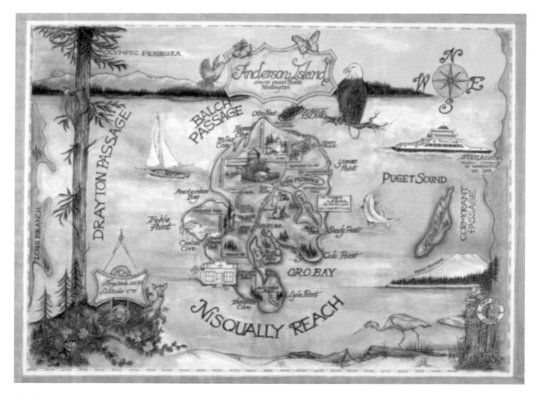

Anderson Island, Latitude 47.15° North, Longitude 122.70° West
(Courtesy of Rosemary Zilmer.)

CHAPTER ONE

Historical Figures

The written history of Anderson Island begins on May 22, 1792, when two longboats under the command of Lt. Peter Puget put into Oro Bay to escape a furious storm that had blown up after their departure from what is today called Ketron Island. Puget had famously been tasked by Capt. George Vancouver of the HMS *Discovery* to explore the inland sea that was subsequently named for him. The published descriptions and maps from the Vancouver expedition led the Hudson's Bay Company, 40 years later, to establish Fort Nisqually, a trading post on the site of present-day DuPont. Company records mention cutting timber on the island for masts and piling, as well as digging clay, perhaps at nearby Jacobs Point, for chimneys. In the spring of 1841, Comdr. Charles Wilkes sailed into Puget Sound with instructions to spy out the land and report back to Washington on its desirability as a future US outpost. During his visit, which was so pleasant he contrived to extend it to two months, Wilkes was generously welcomed and assisted by Hudson's Bay Company personnel, including a Mr. Anderson, the chief trader, a Mr. McNeill, and a Mr. Kittson. He repaid their kindnesses and assured their places in history by naming the adjacent islands in their honor, although "Kittson" inexplicably became "Ketron."

When the Puget Sound region became officially American territory by virtue of the Treaty of 1846, American settlers began to pour across the mountains, looking for land. One of them, young Vermont-born Leander C. Wallace, evidently chose to make Anderson Island his home. When Wallace died in a fracas at Fort Nisqually on May 1, 1849, the island was renamed for him, and was subsequently known as Wallace (or Wallace's) Island until 1889. The official commission appointed to sort out the tangle of place-names after statehood chose to revert to the more official "Anderson Island," and it has been thus to this day.

A few years after Wallace's death, Nathanial Orr, a transplanted Virginian, and Robert Thompson, a man he had met on the mainland, took up claims near the south end of the island and set about clearing them in preparation for farming. Orr spent much of his time working for wages on the mainland, and in the aftermath of the Indian Wars of 1855–1856, made the decision to spend the rest of his days in the bustling young town of Steilacoom. Nothing more was heard of Thompson, and the claims were eventually sold.

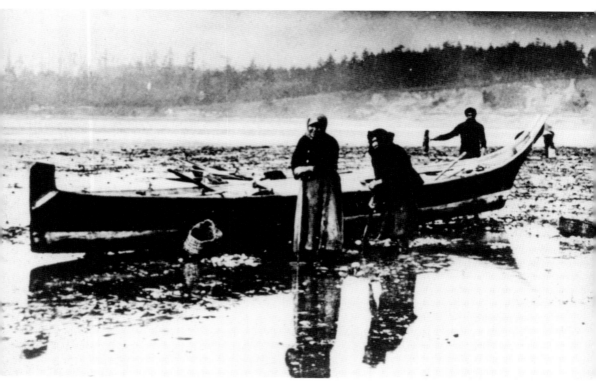

Indigenous Peoples Came First

For thousands of years before the coming of Europeans to the Pacific Northwest, indigenous peoples lived and worked around the shores of the great inland sea known as "the Whulge." In the South Sound, local tribes customarily lived near the water in the summer, digging clams, picking berries, and hunting deer and wildfowl. Anderson Island was called "Klol-Ehk-S" according to Cecelia Svinth Carpenter, a member of the Nisqually tribe with Anderson Island roots.

In several places where streams enter the sound, middens have been found, indicating that shellfish were harvested and processed there. The finding of the occasional "point," or arrowhead, bears mute testimony to the hunting practices of the pre-contact people. The island's erstwhile giant cedar trees were a resource highly valued by the indigenous peoples of the Whulge, who harvested their bark to make everything from rope to clothing, and occasionally felled them to make their long, slender dugout canoes.

The island's early pioneers were witnesses to the life patterns of the indigenous peoples. Bessie Cammon wrote of frequent encounters on the way to and from school with hunters and huckleberry gatherers. It was common in the early days to have unannounced visitors who arrived by canoe, bringing salmon to barter for apples, potatoes, or whatever else the immigrant might have to offer. Gradually, with time, these visits stopped, and the ancient way of life all but disappeared.

In the more than 200 years since Peter Puget rowed around the sound, Anderson Island has been almost completely transformed, but there is still the occasional reminder that other peoples in other times must have loved it much as today's island dwellers do. (Courtesy of Jamestown S'Klallam Tribe.)

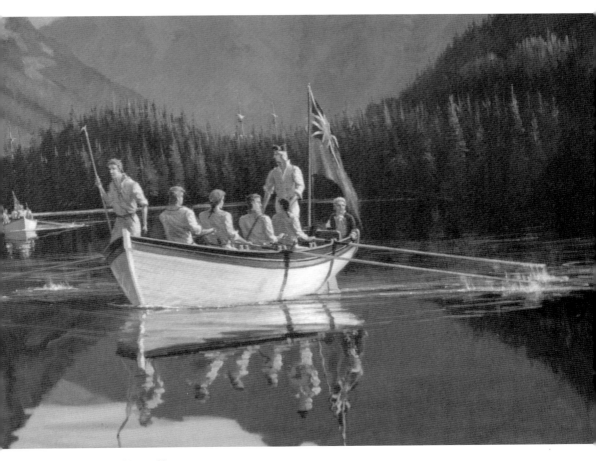

Peter Puget Slept Here

At age 28, Peter Puget was having the time of his life. In the middle of a three-year voyage in the HMS *Discovery* under Capt. George Vancouver, Puget had been instructed to take a crew of men in two longboats and explore the vast, unknown inlet that opened to the south as they lay off of what was later known as Blake Island, on the northwest coast of America.

Puget's orders were clear: keeping the coastline to his right, he and his party were to map the entire inlet or return back to the mother ship in five days. Included in his party were Archibald Menzies, the expedition's botanist, and Joseph Whidbey, a surveyor. On the third day of their assignment, after numerous adventures and some near-disastrous encounters with the natives, Puget and his party were practically swamped by a storm that blew up as they put out from a small island (Ketron). They sought shelter in a protected bay on the east side of what they supposed was another island. Here, they set up camp for the night, whereupon three canoes carrying visitors approached offering fresh vegetables and skins for trade. When the next day, May 23, 1792, dawned foggy, the Puget party delayed its departure until about 8:00 a.m., after which they were followed by more canoes, with whose occupants they carried on a lively trade, to the mutual satisfaction of all.

That bay was almost certainly Oro Bay. However, although Puget later confirmed his hunch about it being an island, it remained for someone else to provide the name, Anderson Island, some 50 years later. He did, however, earn the honor of having the entire body of water south of Bainbridge Island named Puget's Sound in commemoration of his own voyage of discovery. (Courtesy of John M. Horton.)

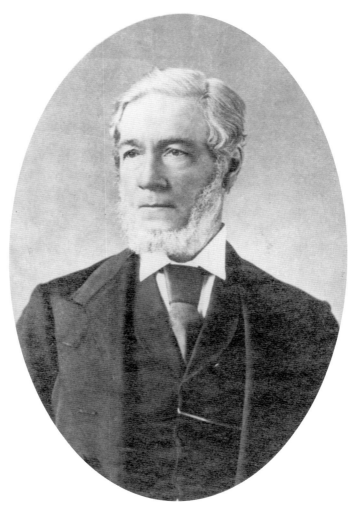

Alexander C. Anderson, the Name

A young man born in India into a family of English expatriots, Alexander Anderson sought adventure overseas from his ancestral home. Signing on with the Hudson's Bay Company in 1824, he was posted to North America, where the fur trade was developing into a real cash cow for the company. Anderson soon discovered that the outdoor life was for him. As he made his way across Canada, he delighted in the scenery and the magnificent geography. He found it somewhat limiting to be assigned to the new trading post called Fort Nisqually near the delta of the mighty river by that name, but he performed his duties meticulously and supervised the establishment of a farm that was conceived to provide produce and trading stock to supply the company's employees.

In the relative isolation and obscurity of Anderson's post, visitors from "outside" were a rarity, so he was pleasantly surprised when Comdr. Charles Wilkes of the US Navy came calling in May 1841. Several exchanges of hospitality ensued, on land and aboard Wilkes's ship. Many toasts were offered, and Anderson generously offered the Wilkes party his support for their obvious mission of snooping around to see what the area had to offer. Upon his departure, a grateful Wilkes attached the name of his newfound friend to the neighboring island. Apparently unaware of this, Anderson left Nisqually after the area was ceded to the Americans, and went on to an illustrious civil service career in British Columbia. (Courtesy of Nancy Marguerite Anderson.)

Charles Wilkes, World Traveler

History has not been kind to Charles Wilkes, but it would be wrong to say that it was not his own fault. A 37-year-old career Navy man, he found himself in command of the United States Exploring Expedition of 1838–1842, with an assignment that dwarfed the expedition of Lewis and Clark. En route to his ultimate destination of Puget Sound and the Columbia River, Wilkes had reached and named Antarctica and crisscrossed the Pacific Ocean, with stops at Fiji and Hawaii. By the time he anchored in Nisqually Reach in 1841, he and his crew had already logged some 25,000 miles and visited places no man had ever seen before. The expectations for his visit to Puget Sound—explore and map the region from the Columbia River to Vancouver Island—paled in comparison to his other orders, but Wilkes went at it with his customary zeal and attention to detail. He found an unlikely supporter at Fort Nisqually in the person of Alexander Anderson, and conducted a thorough exploration and mapping of the entire Puget Sound basin with Anderson's assistance. Wilkes was so unpopular with his crew and fellow officers that they managed to get him sent up for court-martial when they returned to the East Coast, and many of his genuine accomplishments went unheralded because of his unsympathetic nature. Commander Wilkes did, however, succeed in giving the official names for many places and features of Western Washington, not least of which is Anderson Island, followed by most of the other islands of South Puget Sound. (Courtesy of Old Oregon Photos.)

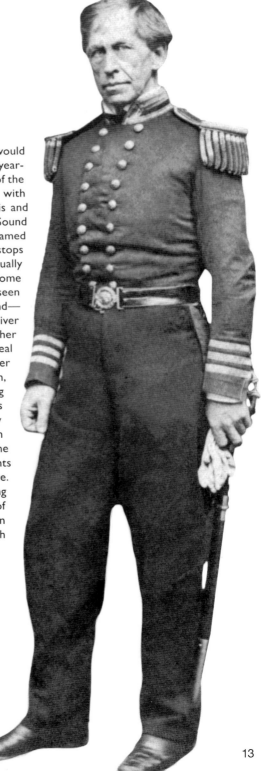

Leander C. Wallace, Wrong Place, Wrong Time

Wallace, a young settler who had come to Puget Sound in 1846, lay dying outside Fort Nisqually. The date was May 1, 1849. A band of Snoqualmies and Skykomish had approached the fort with some kind of mischief in mind. When things started to get out of hand, the British gave the call, "All hands come in and shut the gate," but Wallace and a Mr. Lewis, another American, paid no attention, as they evidently thought the ruckus had nothing to do with them. Shots were fired and several people were wounded, while Wallace and a Skykomish medicine man were killed. This incident set off a remarkable series of events, including the establishment of Fort Steilacoom and the surrender to US military authorities of six Snoqualmies, among whom were two brothers of their chief, Patkanim. The evidence linking Wallace to the island is mostly circumstantial and secondhand. Edward Huggins, a Hudson's Bay employee who became a US citizen, wrote in 1899 that Wallace "had taken up a claim upon what is now called Anderson Island, then named Wallace's Island. The farm is now worked by the Eckensteins [sic], and it is a pleasant place to look upon." No doubt, Huggins was referring to the John Ekenstam farm on Thompson Cove in Section 17. The fact is, however, that Huggins came to Puget Sound in 1851, two years after Wallace's death, so he was merely reporting something he must have heard.

Nevertheless, for whatever reason, the island was known as Wallace Island for the next 40 years. Whether Wallace actually lived on his island may never be known. (Courtesy of University of Washington Libraries, Special Collections.)

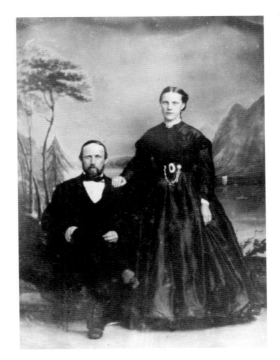

Nathaniel Orr, Wagon Maker

When Nathaniel Orr stepped ashore in Steilacoom on August 24, 1852, he was well prepared to become a prominent citizen of whatever community was fortunate enough to attract him. Just 24 years old, he had graduated from Emory-Henry College in Virginia, where, in addition to academic learning, he had acquired many practical skills such as tailoring, building, and woodworking. Having determined to set out for the West Coast, he stopped in Missouri long enough to learn wagon making. Steilacoom, at that time the most prosperous town north of the Columbia River, was an obvious magnet for an ambitious young man. At first, he rented a building near Saltars Point and set up a wagon shop.

In March 1854, however, he took up a claim on 150 acres on Wallace Island, known today as Anderson Island. The claim comprised most of what is now Andy's Park and part of what later became the Ostling, Long, and Shaw farms, including about half a mile of Schoolhouse Creek. His friend Robert Thompson, also of Steilacoom, took up a claim nearby at the same time. Orr built a cabin on his claim, and was presumably in the process of clearing and improving it when war suddenly broke out with the Indians in October 1855. At this point, he paid cash for the land and promptly signed up to serve in the Washington Territory Volunteers.

Due to the insecure nature of life in the scattered settlements, many pioneer families sought refuge in the more populated areas during the war. This is what Nathaniel Orr eventually decided to do. By 1857, he was building the present house in the middle of Steilacoom, originally setting up his shop on the first floor. His wagon shop, beautifully restored and maintained, is a wonder to see today. Orr, shown here with his wife, Emma, was an active member of the community. He served on the town council, was clerk of the Steilacoom School District, and was one of the original members of the Steilacoom Library Association. He was also a candidate for the territorial legislature in the first few elections and frequently served on juries.

One cannot help but wonder how things might have been different had Nathaniel Orr stayed on his claim and established a farm, orchard, and wagon shop on Anderson Island. With his impressive skills and devotion to community, he might well have attracted others to settle around him. As it was, nearly 20 years passed between Orr's claim and the first permanent settlers, the Christensens, who arrived in the early 1870s. (Courtesy of Steilacoom Historical Museum Association.)

Michael Luark, Writing Logger

Born in Virginia in 1818, Michael F. Luark moved to Indiana and left for the Pacific Northwest in 1853. A man of great physical strength and energy, Luark's place in history is based on the journals he meticulously kept while working as an itinerant logger and prospector, among other trades.

In April 1854, he piloted a scow to Anderson (then Wallace) Island and spent two months cutting and hauling timber to the saltwater. In his spare time, he explored the island, recording detailed observations about the flora, fauna, and terrain. One Sunday, he climbed a "300-foot bluff" and, to his delight, discovered Lakes Florence and Josephine, which he measured and named "the Twin Sisters." "The island," he observed, "would be beautiful for a rich man's retired residence."

Alas, Luark moved on and eventually settled at Sylvia Lake, which he had named "Sylva," near Montesano and built a water-powered sawmill. He and his wife had 13 children, so his name and legacy live on long after his death in 1901. (Courtesy of University of Washington Libraries, Special Collections.)

CHAPTER TWO

Pioneers

As the population of Washington Territory began to boom in the years following the Civil War, land adjacent to bustling towns such as Seattle, Tacoma, and Steilacoom became more desirable and costly. Outlying areas like Puget Sound's numerous islands began to attract interest. A significant amount of Anderson Island had been deeded to the Northern Pacific Railroad, which carved it up in tracts that were then sold to speculators. Few of the first generation of buyers expressed much interest in the island. Indeed, it is likely that many of them never even put boots on the ground in the Pacific Northwest. Among the influx of immigrants were numerous Scandinavians, who had much in common culturally and spoke mutually intelligible languages. Low prices and the maritime setting of the island naturally appealed to them. Many of them cruised around on the steamers that plied the waters of Puget Sound, looking for places to settle. The first to put down lasting roots on Anderson Island were the Christensen brothers, Danes who arrived on Puget Sound around 1870. In all, five brothers took claims on Anderson Island, followed by their lone sister, who had married a German. In due time, they were joined by several Swedes and the occasional Finn or Norwegian.

Though parts of the island had been logged off, the first order of business for most was to clear their land and get in some crops—pasture for cattle and horses, grain for poultry. Several of the newcomers established wood yards on wharves at the water's edge and sold cordwood for the fuel-hungry steamers that plied the sound. Many of them longed for community in their often difficult circumstances, and it was not unusual for the earliest comers to sell off tracts of land to friends they had met along the way for cash or for a certain amount of delivered cordwood.

The new islanders quickly organized a school district, and in 1882, school opened with eight pupils and a full-time teacher in an unoccupied house. Soon, a schoolhouse optimistically dubbed "Wide Awake Hollow" was built on land donated by the Christensens. In the Northern European tradition, the church was the center of community life, and by the 1890s, a sizeable delegation of Anderson Island pioneers participated in building and populating a Lutheran Church on neighboring McNeil Island. Besides the wood yards, which lasted into the 20th century, a brickyard established on East Oro Bay flourished in the early 1890s with a labor force of up to 25, until the depression of 1893 brought construction in the region to a standstill.

The turn of the 20th century found Anderson Island with a population of 95, half of whom were under age 20. Of the adults, nearly 90 percent were foreign-born, the vast majority of them Swedes. But the melting pot was boiling in earnest, and islanders were beginning to dream of building a utopia in their little corner of Pierce County.

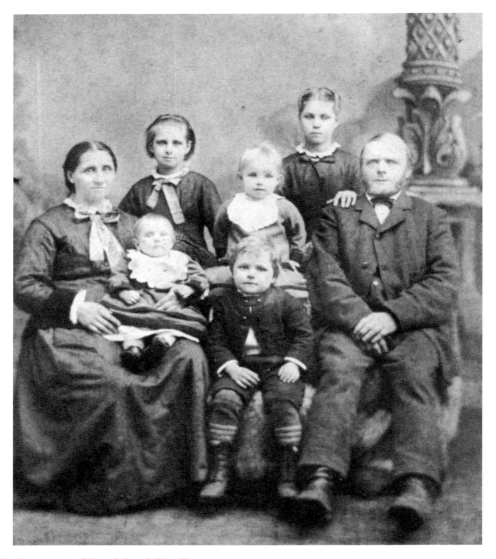

Christensens, First Island Family

The first family to settle permanently on Anderson Island, cousins Christian Christiansen and Helda Cardell, were married in Steilacoom and then rowed to the island to begin their life together. The year was 1872, and Helda was 18 years old. Christian had come to the South Sound after sailing into the San Juans on a Danish ship, where he disembarked and headed south. Other Christensen siblings settled on the island, but in time, they moved to other locations. Christian died at age 46, leaving Helda (age 35) with six children and a seventh (Dora) arriving four months after Christian's death. Then, two years later, Helda married August Lindstrom. They had a son and a daughter. Sadly and inexplicably, August shot their son Conrad and then himself. Their baby Myrtle died the following year, as did 17-year-old daughter Helda Christensen. Despite these tragic events, Helda continued to run the wood yard business, raise her family, and stay active in community affairs. She also became postmistress of the island post office. A post office building was erected by her son Daniel, whose wife, Lena Camus, became postmistress after Helda's retirement. Shown here from left to right are Helda, Christine, Julia, Helda, Daniel, Katherina, and Christian. (Courtesy of Dianne Avey.)

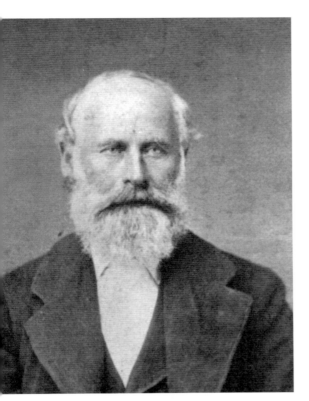

John and Ann Ekenstam, Unusual Pioneers

The Ekenstams, who came ashore on Anderson Island in 1877, were unusual pioneers in several ways. John (left), over 50 years old, had been a successful businessman in Småland, Sweden—not your typical rural youth fleeing the poverty of the old country. He and Ann (right) arrived with seven children, three of whom were nearly grown men, ready to do the hard work of clearing and planting. They had furniture, tableware, implements, and a team of mules. In addition, there was already a small house, a shed, and an orchard on their property, which was likely the same place Leander Wallace had settled some 30 years earlier. On these auspicious beginnings, the Ekenstams built a lovely farm and raised a family that, through triumph and tragedy, contributed in important ways to the history and culture of Anderson Island. The Ekenstam name lives on in Ekenstam-Johnson Road, the "main" road that connects the north and south ends of the island. (Both, courtesy of Dianne Avey.)

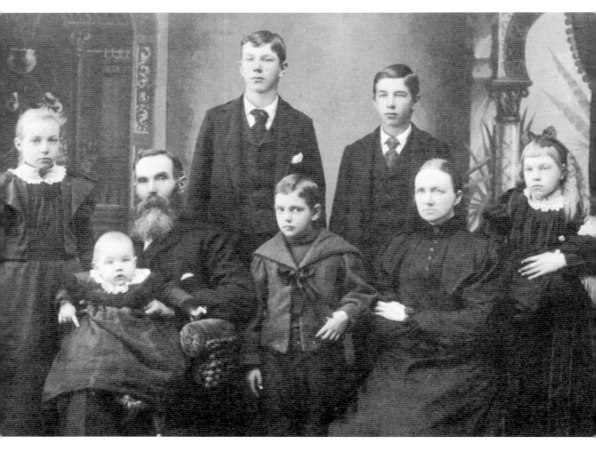

Bengt and Anna Johnson, Johnson's Landing

In 1862, Bengt Johnson left Sweden for America, settling in Kansas, where he established a farm. After meeting his soon-to-be bride at a nearby neighbor's home, he and Anna Nelson were married. In 1881, they chose to sell the farm to begin a new life out west. A train ride to San Francisco and a cruise aboard the steamship *Idaho* brought them to Seattle. Opting to live near Puget Sound and learning of Wallace (Anderson) Island, they purchased over 400 acres. They cleared brush, felled trees, and hewed logs for the building of their first island home. Bengt soon saw a need, and began a business selling the cordwood from his land to the steamboats, known as the Mosquito Fleet. He served as the island's first postmaster and as clerk for the school board when the first school opened. The Johnsons raised six children and lived out their lives on Anderson Island, helping mold its way of life. Shown here are, from left to right, Augusta, Otto, Bengt, Gunnard, Ben, John Peter, Anna, and Betsey. (Courtesy of Anderson Island Historical Society.)

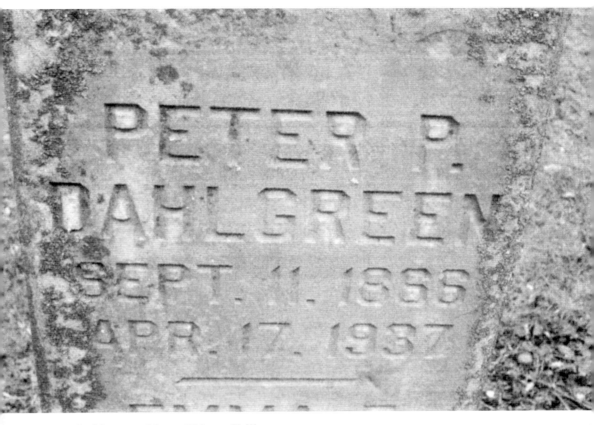

Peter Dahlgreen, Man of Many Skills

In 1889, the year Washington became a state, Peter Dahlgreen and his friend Charles Alward rowed around the island and found a 50-acre piece of waterfront property owned by Nels Petterson. Both bachelors at the time, they purchased it with the understanding that if one of them died, the other would continue making payments.

Not every person who builds a boat also builds its engine. A skilled pattern maker, Dahlgreen constructed the parts for a 40-horsepower engine. Castings and other components for the engine were turned over to the Wright Repair Company for assembly and installation in his boat. He named this new boat *It II*. Dahlgreen made patterns for ship propellers ranging in size from 10 inches for smaller craft to 22 feet for oceangoing vessels. The *Flyer*, known for its speed, had a Dahlgreen propeller.

Dahlgreen was a competent skipper of his 50-foot ship, the *Anna Florence*, and her successor, the *Queen*. He transported goods to and from the island, shrimped, and was a successful farmer. Even during hard times, he always had the skills needed to sustain his family. (Courtesy of Anderson Island Historical Society.)

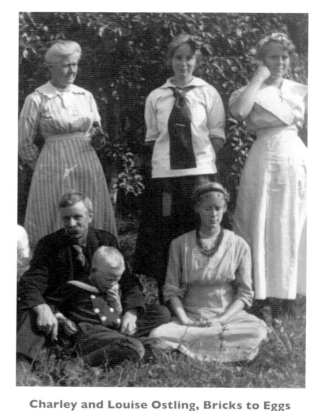

Charley and Louise Ostling, Bricks to Eggs

Born in Sweden, Carl "Charley" Ostling came to America as a teenager with his parents, settling first in Nebraska. After a few years of farming and working on a railroad spike gang, he came to Washington in 1886. Charley found work at Johnson's Woodyard and at the island brick factory. Louise was the daughter of John and Ann Ekenstam. Louise and Charley married in 1894. "A handsome young blond," as Bessie Cammon described him, Charley Ostling was ambitious. He purchased unimproved land on East Oro Bay, where he and Louise developed "one of the finest and most productive farms on the island." Their four children attended the island school and went through high school in Tacoma. Their daughters Edna and Evangeline often sang at community events in a quartet with Sidor and Harry Johnson. Shown above are, from left to right, (seated) Carl, Allan, and Evangeline; (standing) Louise, Edith, and Edna. At left, Charley holds his grandson, Carl Ostling. (Both, courtesy of Dianne Avey.)

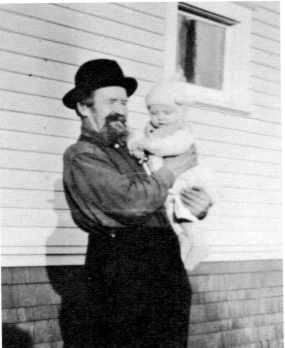

John and Christine Brolin, Skilled Workers

John Brolin and his wife, Christine (above), left Sweden with their two children, Victor and Anna, in 1887, and found their way to the island by about 1890. They were both skilled in crafts; John was a woodworker, and Christine was known for her woven rugs. Laborers from the nearby brickyard boarded at their home, and the Brolins tended a poultry and dairy farm. John Brolin, shown at left holding his grandson Carl Carlson, served as clerk of the Anderson Island School Board and president of the cemetery association. Never a dull moment! (Both, courtesy of Rick Anderson.)

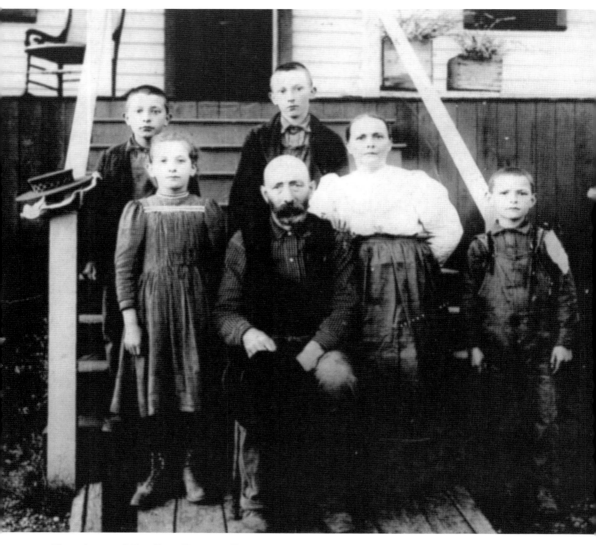

Maurice and Pauline Camus, Truck Farmers
Morris "Maurice" Camus immigrated from Switzerland in 1888, and his wife, Pauline, came from Germany in 1889, according to answers they gave to a census taker in 1930. They both listed their mother tongue as German. They arrived on Anderson Island around 1891, according to Bessie Cammon, about the time the first of their five children was born. They farmed near Amsterdam Bay, specializing in fruits and vegetables, which they transported by boat to Tacoma and Seattle. Morris Camus Jr. recalled that it was normal for them to have over 1,000 tomato plants each year. Shown here are, from left to right, (first row) Lena, Morris, Pauline, and Morris Jr.; (second row) Paul and Henry. (Courtesy of Anderson Island Historical Society.)

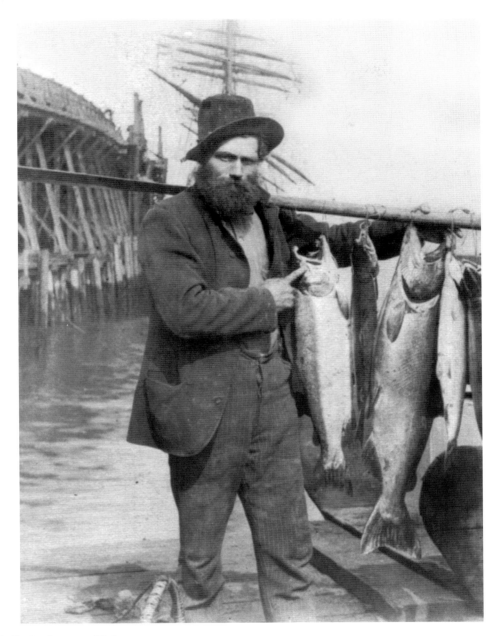

Erik Anderson, Fisherman

Erik Anderson and his wife, Else Marie, came to Anderson Island in 1895, living aboard a scow house that they had towed from Case Inlet. A fisherman born in Denmark, Anderson had been looking around Puget Sound for somewhere to settle, finding a place that suited him on Oro Bay. There he bought 10 acres and established a farm while his family lived on the scow house. Tragedy struck when their youngest son, Alfred, died at the age of three, but the family carried on through difficult times with the support of the island community. Erik fished around Puget Sound and, each spring, he and his friend Charley Carlson would row and sail up to Canada to fish during the Fraser River Salmon run. The beautiful Anderson homestead was eventually taken over by daughter Christine. (Courtesy of Randy Anderson.)

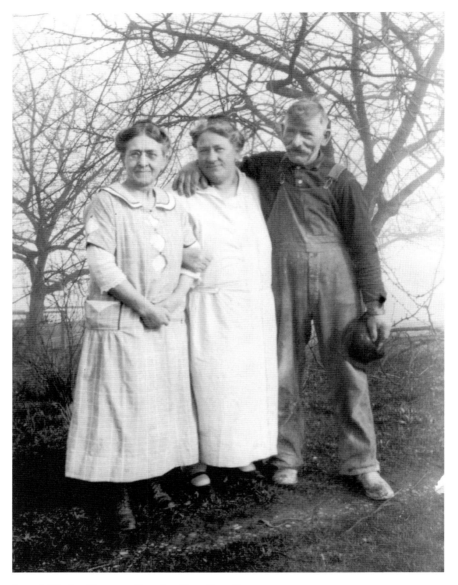

August and Alphy Burg, a Productive Family

August and Alphy Burg purchased Anderson Island property from Loomis and Baer of Steilacoom. In October 1897, they moved with their four children into a one-room scow house perched on the beach in front of their property. The coming winter was motivation to quickly complete a more permanent dwelling. By the spring of 1898, their home was built, the well was dug, trees and brush were cleared, an orchard and garden were planted, a herd of goats established, and cows and a small flock of chickens roamed the land. August pursued several professions off-island, but found that rowing a small boat four miles to and from the mainland dampened his enthusiasm. When the C.B. Hopkins family purchased island property, August took a job as caretaker, drastically shortening his commute.

August and Alphy lived out their lives and raised seven children on the island. Burg ancestors still reside on the island, and those unable to live on the island visit frequently. Shown here are, from left to right, Anna Mahlberg, Alphy, and August. (Courtesy of Carol Shearn.)

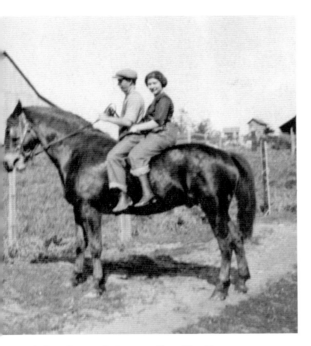

John Oscar Johnson Family, Farmers

In the photograph on the left, Rudy and Ruth Johnson ride across the south 40, which eventually became the island's museum. Draft horses were the preferred source of power as the immigrants cleared their land and hauled timber and farm produce, although some had oxen. In the right photograph, posing in the backyard of the farmhouse are, from left to right, siblings Rudy, Ruth, and Oscar Johnson, and Ruth's husband, Al Laing. This was a very supportive family. After Ruth's death, Al and daughter Alma Ruth Laing returned to Tacoma and continued to help Oscar and Rudy with the farm.

The Johnson Farm was established in 1896 by John Oscar and Alma Marie Johnson, both Finns of Swedish extraction. They met at the Swedish Lutheran Church in Tacoma, where the Bengt Johnsons were charter members. They bought 40 acres from Bengt and Anna and built a two-room cabin with the $50 they had saved. They paid for the property by cutting cordwood for Bengt.

They had four children, Alida, Oscar, Ruth, and Rudy. Sadly, Alma died when Rudy was only four years old. Alida dropped out of school to care for Rudy and help with household duties. She graduated from the Tacoma General School of Nursing in 1922. John Oscar was active in the community, school, church, and cemetery association. He and Oscar John (age 16) constructed a large pole, board-and-batten, and hand-split shake barn from island trees. It is now in the state's historic register. (Both, courtesy of Anderson Island Historical Society.)

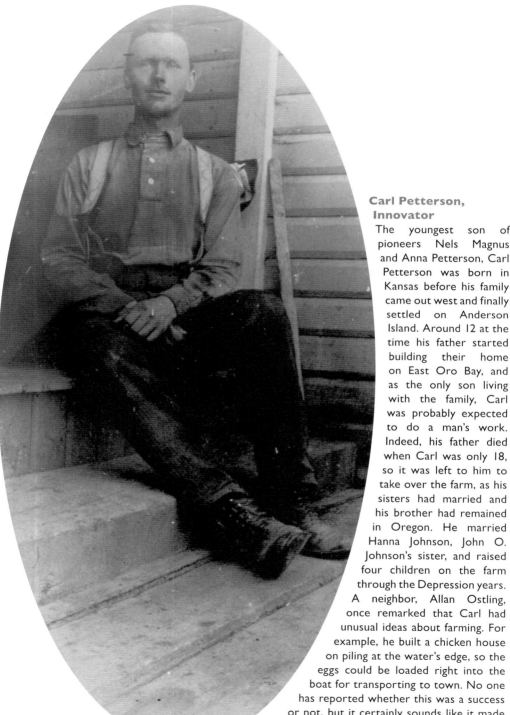

Carl Petterson, Innovator

The youngest son of pioneers Nels Magnus and Anna Petterson, Carl Petterson was born in Kansas before his family came out west and finally settled on Anderson Island. Around 12 at the time his father started building their home on East Oro Bay, and as the only son living with the family, Carl was probably expected to do a man's work. Indeed, his father died when Carl was only 18, so it was left to him to take over the farm, as his sisters had married and his brother had remained in Oregon. He married Hanna Johnson, John O. Johnson's sister, and raised four children on the farm through the Depression years.

A neighbor, Allan Ostling, once remarked that Carl had unusual ideas about farming. For example, he built a chicken house on piling at the water's edge, so the eggs could be loaded right into the boat for transporting to town. No one has reported whether this was a success or not, but it certainly sounds like it made things interesting for the hens! (Courtesy of Anderson Island Historical Society.)

CHAPTER THREE

Pillars of the Community

As Anderson Island grew from an isolated outpost to a nearly self-sufficient community, a distinctive culture emerged. This was a natural response to the sheer necessity of mutual support in the struggle to survive in challenging conditions. To this mix of collective skills, strength, and energy was added the inevitable brew of diverse characters and personalities, habits, and temperaments. On authority from Bessie Cammon, whose adult life spanned most of the 20th century, the islanders were for the most part a hard-working breed who knew how to get things done and enjoyed working and playing together. Stores and post offices came and went with regularity. As the need for more complex organizations grew, the community rose to the challenge, and leaders emerged who became veritable pillars of the community.

Hard on the heels of solving the most pressing need, a school district, the islanders created, in turn, a formal church, a cemetery, and, in 1904, the Utopian Social Club of Anderson and McNeil Islands, drawing on the human resources of both islands. After a few years of fundraising, through pie socials and auctions, a hall was erected on property donated by Dan Christensen. Succeeding years saw the establishment of the Ladies' Improvement Club and the evolution of the two organizations into the Anderson Island Community Club. These clubs saw to it that the island was provided with everything the growing community needed, such as a telephone system and an impressive welcome sign at the ferry dock. One side read "Anderson Island;" the other, "Come Again."

As Anderson Island modernized, new organizations sprung up. The 1960s witnessed the introduction of public power by Tanner Electric Cooperative of North Bend, and the creation of a park district. Soon after, a volunteer fire department and a historical society were formed. Today, there are nearly two dozen formal community organizations, mostly dedicated to meeting the practical needs of a community isolated from "the continent" by several miles of water. The services provided by the islanders through these organizations truly represent labors of love.

Christine Anderson, Carrying On

Christine Anderson (top), the daughter of Erik and Else Marie Andersen, was born on Oro Bay in 1898. She was quite literally born "on the bay," as her family was living in a scow house secured in front of their property. She grew up to eventually take over the family poultry and dairy farm, taking time along the way to complete the WSU Extension Service's poultry school in Puyallup in 1922 and climb Mount Rainier in 1926. She was long remembered for saving the life of a New England schoolteacher who nearly fell into a crevice during the expedition. Anderson famously served as an officer in virtually every island organization of her day, including acting as president of the Anderson Island Community Club and secretary of the cemetery association (from 1933 to 1978). One of the last active farmers on Anderson Island, she was so highly regarded that a poll of islanders resulted in the new county ferry being christened *Christine Anderson* after her passing in 1993. Shown at bottom are, from left to right, Ralph Christensen, Christine Anderson, and Bob Ehricke. (Top, courtesy of Terry Bibby; bottom, courtesy of Anderson Island Historical Society.)

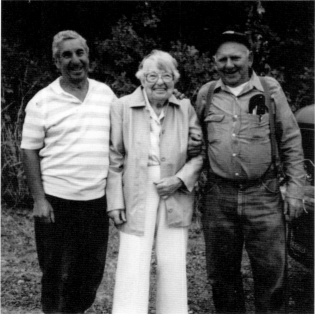

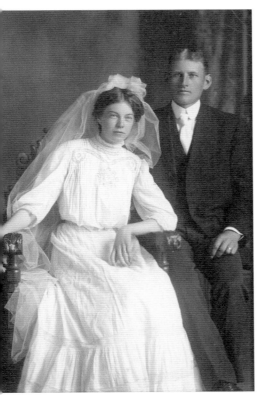

Bessie Cammon, Island Leader

The daughter of island pioneers Bengt and Anna Johnson, Bessie Cammon, shown at left with her husband, Oscar Cammon, lived out her life on Anderson and McNeil Islands and authored the definitive *Island Memoir*. Much can be written of Cammon's island leadership. A story fondly told regards her organization of the Youth Fellowship Group. In the early 1950s, the group met weekly in summer and monthly in winter. One spring day, Cammon informed the group that it could either put on a play or publish a newspaper. Unanimously choosing the newspaper, the members set about organizing their project. Through the sale of subscriptions, they purchased a mimeograph machine, ink, stencils, and a paper cutter. Newsprint roll ends were donated by Chambers Creek pulp mill. Reporters gathered news, granddaughter Jean edited, and Bessie composed the news and stories on her manual Remington typewriter. After paper was cut to size, the *Gazette* went to press. Today, copies of each edition of the *Gazette* and Bessie's Remington typewriter are on display at the historical society. Below are, clockwise from front left, Gary Robinson, Darlene Burg, Merlene Armstrong, Jean Cammon, and Bessie Cammon. (Both, courtesy of Anderson Island Historical Society.)

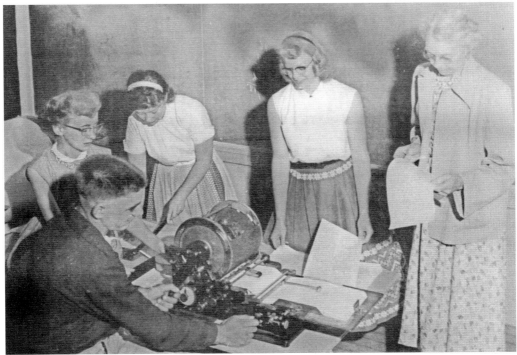

Lois Scholl, Community Catalyst

Born Lois VanBuskirk in Missouri in 1896, Scholl moved with her family to Tacoma in 1901, where she lived most of her life. She married Luke Scholl in 1919 and, for many years, operated the Scholl Fur Company in North Tacoma. Widowed in 1948, she moved to Anderson Island in 1970, where she became a pillar of the community in many ways. The most obvious one was as founder of the Anderson Island Historical Society. She befriended Rudy Johnson, last of the bachelor Johnson brothers, who ran a dairy and poultry operation on Otso Point Road. When Lois suggested that the farm should someday become a museum, Johnson would chuckle and downplay the idea. When he died in 1975, she prevailed in her kindly and practical way upon Alma Ruth Laing, Rudy's niece, and her father, Al Laing, encouraging them to consider allowing the farm to become a museum. And so it did. Lois Scholl is remembered for her gift of spreading joy wherever she went, in spite of the hardships and personal tragedies she experienced. Scholl, shown at left in the photograph on the right, and below, passed away in October 1994, 98 years young. (Both, courtesy of Anderson Island Historical Society.)

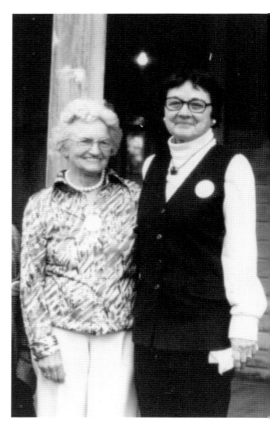

Hazel Heckman, Island Chronicler

Born in Kansas in 1904, Heckman came west with her husband, Earle, in the summer of 1946. He had been hired by Atlas Foundry of Tacoma, which happened to own the former Ostling farm on East Oro Bay. The Heckmans quickly succumbed to the charms of Anderson Island and bought their own place, Bill Baskett's homestead on the east side of the island. When Earle retired, they made their home on the island.

Hazel, who had published several articles in national magazines, quickly penned two classic books: *Island in the Sound* and *Island Year*. Her keen powers of observation of flora and fauna and of human nature were well applied in capturing the beauty of the island and the wonderful characters who populated it. Many honors came her way, including an honorary doctorate from the University of Puget Sound. Hazel was active in numerous island organizations. She passed away in 2002 at the age of 98.

Part of her legacy is her love of the island, its people, and her commitment to service. Her son and daughter-in-law also served in that same spirit. Jim Heckman, a photographer for the *Seattle Times*, recorded island history with his camera; and Liane Heckman is still a leader in the community club, historical society, and other organizations. (Both, courtesy of Liane Heckman.)

Andrew Anderson, Only Nice People

Born while his family was living in a scow house at Victor, Washington, Andrew Anderson grew up on the Anderson homestead on Oro Bay. He attended the island school and, as a young man, went off to seek work in logging camps and mills. For years, he returned to the island on weekends and whenever possible to help his sister Christine operate the family farm. A physically powerful and imposing man, his somewhat gruff exterior concealed a tender heart for his family, his fellow islanders, and the island. Anderson was among the visionaries who created the Anderson Island Park & Recreation District in 1968, just in time to take ownership of the Old Schoolhouse and its surrounding acreage before they were absorbed by the Steilacoom School District. His thrifty ways and foresight led him to purchase several large tracts of island real estate at tax auctions in the 1930s. Later, he donated them to the park district, and they became the nucleus of two of the island's most popular parks, aptly known as Andy's Park and Andrew Anderson Marine Park. Andrew Anderson never said an unkind word about anyone, and he had a favorite saying: "I only know nice people." (Courtesy of Candyce Christine Anderson.)

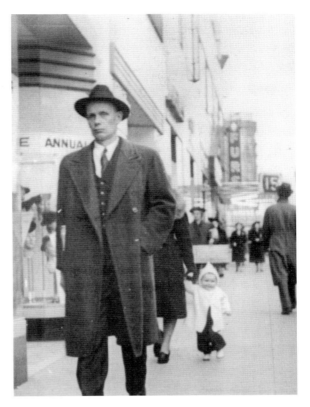

Johnson Brothers at the Farm

Bachelors Rudy (left) and Oscar Johnson (above) continued to run the farm after their parents' deaths. The two Johnson sons provided more than milk and eggs for the community and the mainland—they were active in the nondenominational church and island school district, were sextons for the cemetery association (as was their father), and busied themselves meeting the everyday needs of residents. Many island youths worked at the Johnson Farm and benefited from their example of hard work and business ethics. Eggs and dairy products were sold well below the market price to island residents and neighbors, who drove around to the back of the house to pick up their order. Island residents received their bills as much as a year late, and only by the consumer's request. Oscar died in 1969, and Rudy continued to run the egg business. Alida Johnson Svinth, who had returned home to the island after the loss of her husband, died in 1973, and Rudy died in 1975. The Anderson Island Historical Society was founded by like-minded residents who knew the Johnsons and who wished to honor the memory of the island pioneers. (Courtesy of Anderson Island Historical Society.)

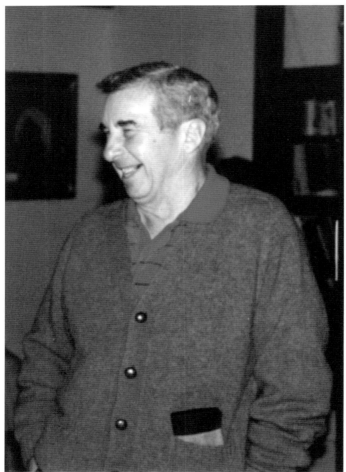

Ralph and Lorainne Christensen, Counting the Catch

Both Ralph and Lorainne Christensen were very involved in the beginnings of the historical society. As its first treasurer, Lorainne attended a finance class at the University of Puget Sound to better prepare herself for the role. Ralph (left) was the third generation of the first family to settle on the island. Lorainne was also active in the Anderson Island Community Club and the cemetery association. In 1976, with the establishment of the historical society, the traditional Salmon Bake moved from the Christensens' beach to the Johnson Farm. Shown below are, from left to right, Lorainne Christensen, Otto Johnson, Paul Camus, Ralph Christensen, Marion Stimmel, and Ralph Engle. (Left, courtesy of Terry Bibby; below, courtesy of Anderson Island Historical Society.)

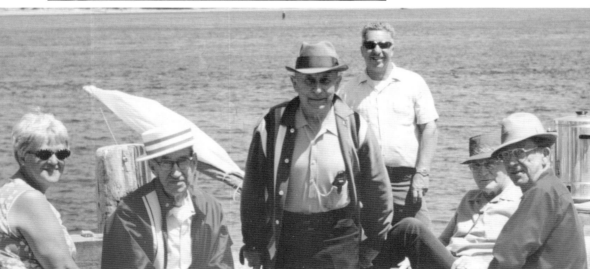

Alma Ruth Laing, Remembering Family

Alma Ruth (below right and above center), the daughter of Ruth Johnson and Albert Laing and granddaughter of the founders of Johnson Farm, deeded approximately six acres on which all the buildings stood to the Anderson Island Historical Society in 1975. Through the years, she has continued to attend island events and helps with lunches for the work parties, setting the tables, ringing the dinner bell to summon the workers to lunch, and helping clean up afterward. Alma Ruth and her mother spent many summers helping her uncles run the farm. She is pictured below left with her parents. (All, courtesy of Anderson Island Historical Society.)

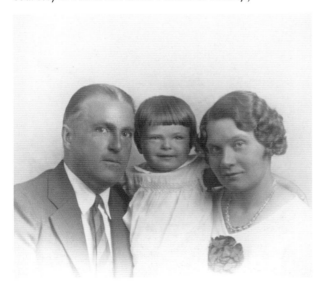

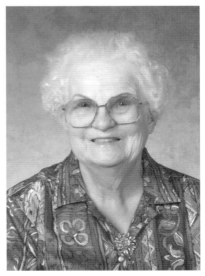

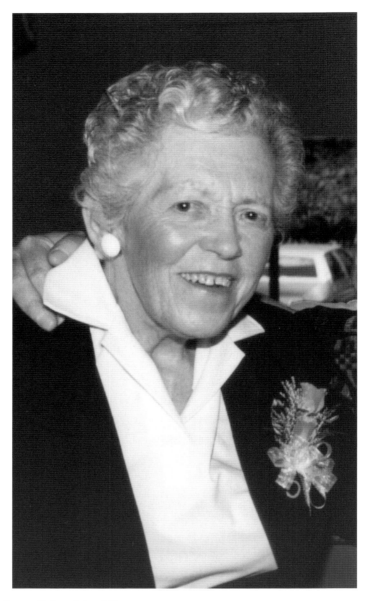

Evelyn Morrison, Friend to All

Evelyn Morrison and her husband, Jim, moved to the island in 1976. She was soon volunteering for many community organizations. She held several offices within the community club, served on the park board, was president of the historical society, president of the Homeowners Association, and participated in their committees and functions. Morrison loved to sing and took every opportunity to perform. A voracious reader, she often read 15 to 20 books a week. Island librarians often delivered books to her home. She loved photography and never left home without her camera in hand. Today, her collection of photographs is a tremendous asset and resource documenting years of island history. With her love of animals and kind heart, she faithfully fed the raccoons and feral cats that lived in the woods near her home. Evelyn was loved by many and was a friend to all. (Courtesy of Andy Hundis and Anderson Island Community Club.)

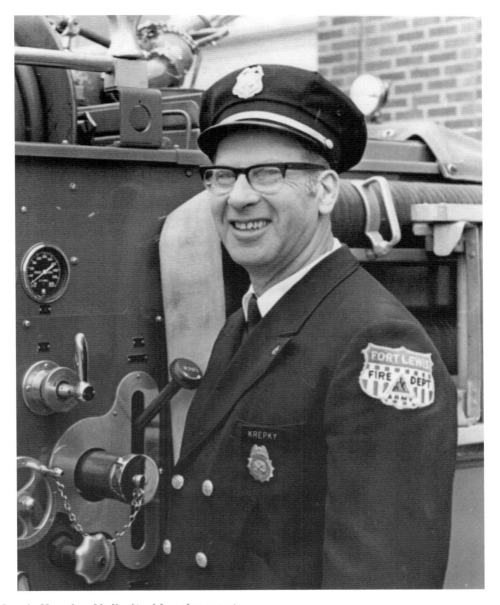

Morris Krepky, Unlimited Involvement
During the Great Depression, motivated by the thought of three square meals a day, Krepky fibbed about his age and joined the New York Army National Guard. He went on to serve in the 3rd Infantry Division and was awarded a Purple Heart in World War II. For many years, he continued a long association with his 3rd Division buddies. In 2004, at the 3rd Infantry Division Reunion, Krepky received a service award for outstanding and dedicated service at the local and national Levels. He retired as fire chief of Fort Lewis, Washington, command sergeant major of the Washington State National Guard, and the adjutant general's chief advisor on enlisted men's affairs. In 1977, Morris and his wife, Ruth, moved to Anderson Island. He was instrumental in organizing the Anderson Island Fire Department. Morris Krepky loved the "island way," and his community involvement was limitless. (Courtesy of Anderson Island Fire and Rescue.)

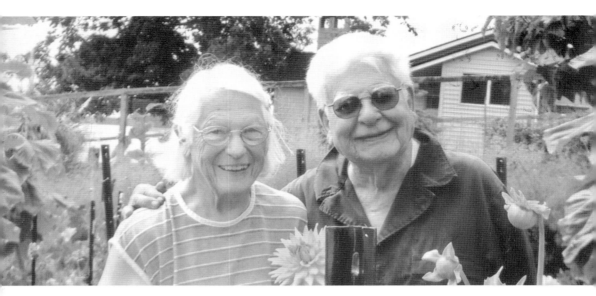

Jean and Earl Gordon, Welcomers

The Gordons, famous for their extensive dahlia garden, give large bouquets to boaters passing their Amsterdam Bay home. Earl is well known for turning historical spurtles in his immaculate workshop. The Gordons were instrumental in arranging early displays in the museum, labeling the items faithfully. Both have been hard workers in all areas of the historical society, including the dirty work, such as scrubbing the tool shed floor on their hands and knees. Earl and Jean have hosted their church's summer picnic on their property for many years, and their home was one of five selected for the island garden tour. Their most recent project was helping islanders write their family histories. (Courtesy of Anderson Island Historical Society.)

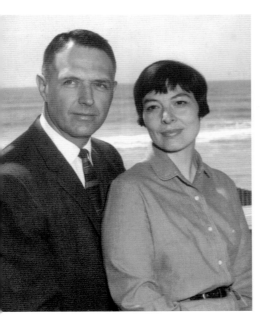
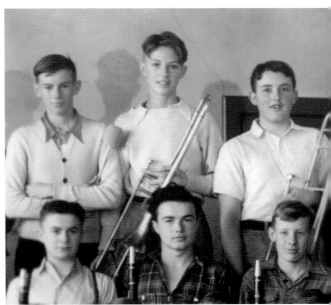

Randy Anderson, Nearly an Admiral

Randy Anderson, the grandson of pioneers Erik and Else Marie Anderson, grew up in Tacoma and graduated from Stadium High School at age 16. During his teen years, he developed his ties to the island while working on the family farm, then managed by his aunt Christine and uncle Andrew. To placate his mother, who insisted that he keep up with his trombone lessons all summer, Randy (in the image on the right, back row, center) rode the ferry and bicycled, with his trombone, to North Tacoma and back once a week, hoping that someone would cover for his chores. He earned a bachelor's degree in mechanical engineering from the University of Washington at age 19. While working for the highway department in Wenatchee, he met and married a local beauty queen, Bettymae Sperry, pictured with him on the left. He joined the Navy and was assigned to naval intelligence at the Pentagon. Randy worked for Alcoa for many years, including stints in Dallas and Los Angeles, all the while continuing to serve in the naval reserves, where he nearly made admiral. Retiring to live full-time on the island in 1994, he really got busy, serving on the park board and the Tanner Electric Cooperative Board of Directors, and holding several positions in the historical society, where his patient and good-natured approach to problem-solving were much appreciated. He also found time to establish Anderson House, one of Western Washington's premier bed-and-breakfasts. Some retirement! (Both, courtesy of Randy Anderson.)

Bob and Yolanda Nelson, Supporters

One cannot look at a Model T without remembering Bob Nelson. He was an early participant in the historical society, and anything to do with mechanics was his forte—especially the unique apple squeezer, various tractors, and the Model T. Still on display are instructions Nelson wrote for starting the old Ford. After reading the directions, most people demur. "Jack up the back wheels?" Each fall, Nelson grew a Santa beard and, following Rudy Johnson's example, held court and heard island children's wishes during the holiday season. Yolanda Nelson was part of the team of ladies who started the gift shop at the Anderson Island Historical Society museum, and she continues to support the society's events and activities. (Both, courtesy of Anderson Island Historical Society.)

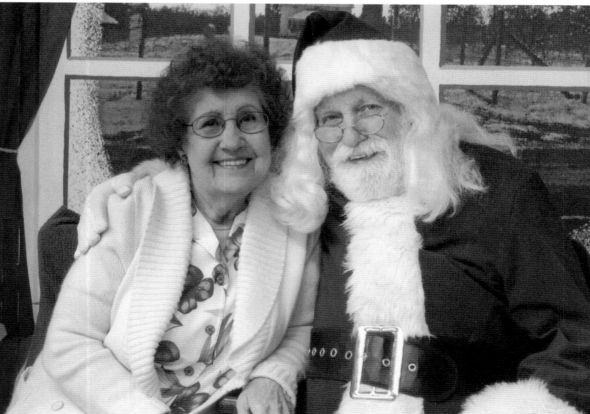

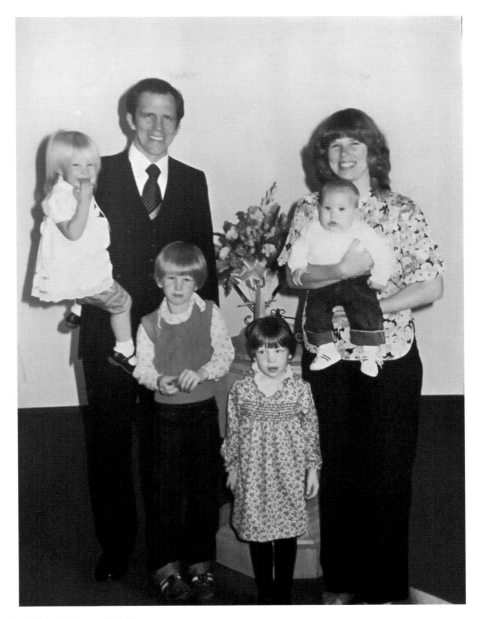

Pastor Mark Benz, FILC
A combat veteran of the Vietnam War, Mark Benz completed his studies at Faith Lutheran Seminary in Tacoma before moving to the island with his wife, Deb, and two children in 1981. Three more children were born to them during his time as pastor of Faith Independent Lutheran Church. The family has fond memories of their sojourn as islanders, especially the many community activities and outdoor recreation. Pastor Benz served as a volunteer fireman and performed baptisms, weddings, and funerals on the island. On Sunday afternoons, he traveled to McNeil Island by canoe to minister to those living there. In 1986, he was "drafted" again into the Army, this time as a chaplain. He served 20 years and retired in the Washington, DC, area after completing his last assignment at Walter Reed Hospital. (Courtesy of Mark Benz.)

Larry Gordon, Booster

Larry Gordon grew up in the Chelan area of Eastern Washington. His parents, Don and Mabelle, bought property on Anderson Island and took over the Dock Lunch in the 1940s. After a tour of duty with the Navy Seabees in World War II, Gordon moved to the island and married Vivian Johnson, the daughter of John and Alice Johnson. He found work as a guard at McNeil Island Federal Penitentiary and settled down to raise four children. Larry and Vivian were active in community affairs and worked hard to bring progress to the island. They circulated a petition seeking modern telephones, and in 1953, the first telephone connected to the outside world was installed at their home on Larson Road. After working diligently to bring electric power from the mainland, Gordon became a member of the Tanner Electric board of directors after Tanner agreed to serve Anderson Island. When the Anderson Island Park and Recreation District was formed in 1968, he was elected to the board of commissioners. He served on the board of Anderson Island School District No. 24 for a number of years and was a member of the Riviera board of directors. In retirement, he and Vivian served as camp hosts at First Creek State Park on Lake Chelan for a number of summers. There were many changes during the years 1946–1968, and Larry Gordon, shown below with his wife, Vivian, was at the forefront of most of them. (Courtesy of Vivian Gordon Skagerberg.)

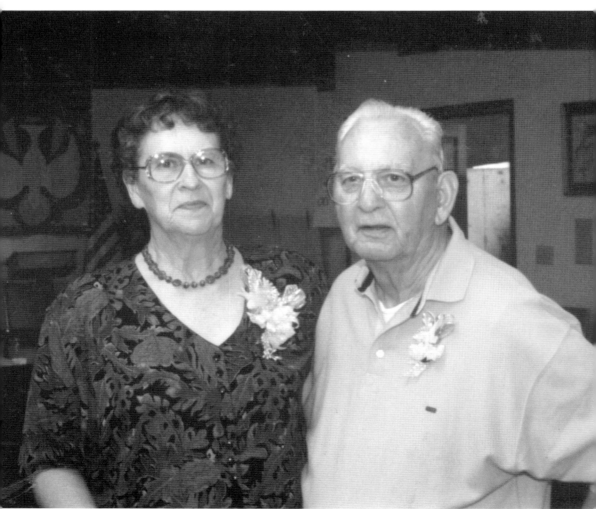

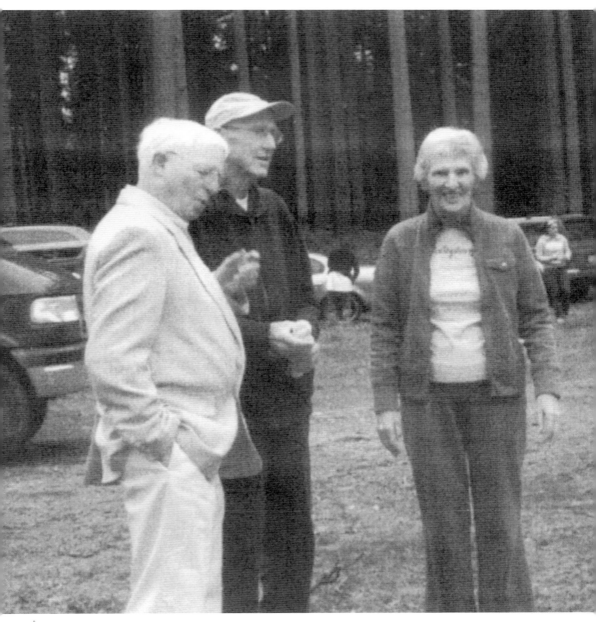

Allen and Thelma Billett, a Gift to the Community

Allen and Thelma Billett were themselves a gift to the community. Allen, an attorney and judge, served on the Tanner Electric board of directors, was part owner of the island store, and was president of the Homeowners Association. He donated not only his time, but his professional skills as well. Thelma was also on several boards and organization committees serving island residents. When the Anderson Island Christian Fellowship was searching for a site to build a church, the Billetts donated five acres of beautifully wooded property in a prime location. Their gift keeps on giving, because this congregation makes its debt-free building available to island organizations for meetings and get-togethers. Here, Allen (center) and Thelma (right) chat with church elder Cliff Purdy. (Courtesy of Anderson Island Historical Society.)

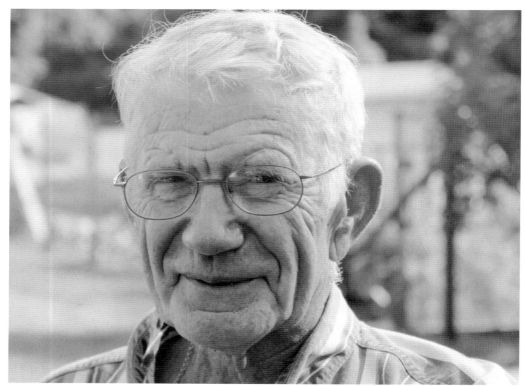

Dick Throm, Sharing Knowledge

The Throm farm, adjacent to the historical society's Johnson Farm, is a model of best conservation practices. Chickens, mason bees, honeybees, Christmas trees, fruit trees, and vegetables are maintained and produced using state-of-the-art methods. Dick Throm's plan provides for year-round eating and is generously shared with others. Each December, he hosts a dinner in his home as volunteers come to assemble holiday wreaths and swags and then deliver them to families in the community. Master of many trades, Throm shares his knowledge about farming, engineering, design, and construction with his fellow islanders. He is internationally known, having been the Food and Drug Administration's principal organoleptic expert. Throm is still in private practice. His specialty is teaching people the art of judging the quality of fish, shrimp, and other seafood products using a variety of chemical and sensory examinations. (Above, courtesy of Anderson Island Historical Society; left, courtesy of Dick Throm.)

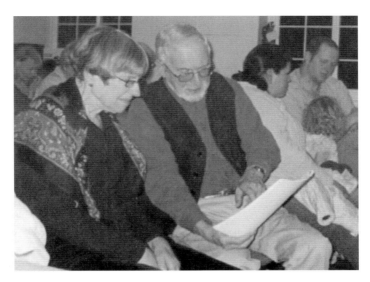

David and Jane Groppenberger, Inspired by a Book

After reading Hazel Heckman's *Island in the Sound*, Dave Groppenberger (above, center) decided to visit Anderson Island and see for himself if such a wonderful place could exist. He was so smitten that he selected a piece of property and brought Jane (above, left) out for a visit. She agreed to the purchase, but added, "Don't expect me to move here full time!" Famous last words! They moved to the island when Dave retired in 1997. He had been part of the team that planted the Johnson Farm Orchard in 1993, and he has faithfully mowed and trimmed the farm lawns and fields for decades. He is the Dragon Whisperer, keeping the historical society's unique apple-cider press operating smoothly. Jane, a professional garden designer, volunteered her plans and labor to restore the Johnson Farm pond after a disastrous winter storm. Native plants have been replanted and labeled after the area was cleared of fallen trees to restore the habitat. Jane manages the farm's weekly Garden Market, which has become an island institution, and her own community garden patch is a showcase for other gardeners and visitors alike. Shown below are, from left to right, Chuck Rogers, Jim Ray, Bob Nelson, George Very, Paul Jacobsen, unidentified, Ken Shaffhauser, Chappy Chapman, Russ Cammon, Bob Cammon, Robert Smith, and Ray Walberg. David Groppenberger is kneeling in front. (Courtesy of David Groppenberger.)

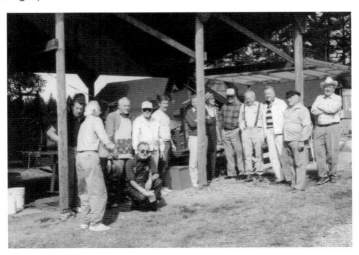

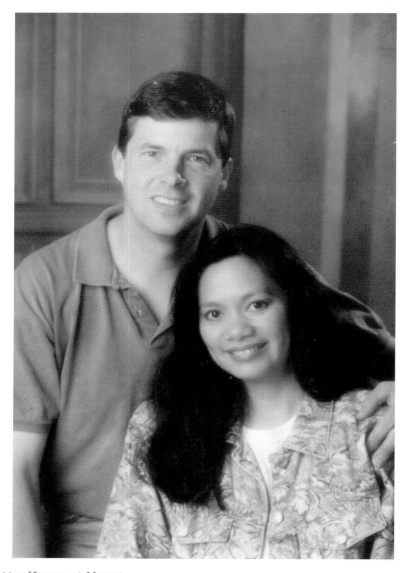

Jeff Gillette, Young at Heart

Growing up in Eastern Washington, Jeff Gillette's life took an unexpected turn on a holiday visit with his parents at their island vacation home. On New Year's Eve 1978, he and his wife, Joyce, met the owners of the Anderson Island Mini Mart. Hearing that Jeff worked in a grocery store in Cordova, Alaska, it was jokingly suggested that the young Gillettes purchase the convenience store on the island. So, four months later, on April Fool's Day, the adventurous young pair experienced their first day as business owners. Over the years, Jeff and Joyce worked to transform the store into a true old-fashioned general store. Their planned two years soon turned into 30, during which time the Island General Store became an iconic fixture of island life. Somehow, they found time for Jeff to serve on the park board, his church board, and the Tanner Electric board of directors, while volunteering for Young Life and raising three community-minded children. Since selling "the Store" in 2009, Jeff has taken the staff position of Young Life on the island, working to break down generational walls and help island teens become a relevant part of their community. (Courtesy of Jeff Gillette.)

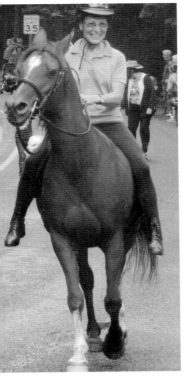

Dave and Jeanne McGoldrick, Horses and Horsepower

The McGoldricks both grew up in Tacoma, with roots there going back many years. Their move to the island marked the beginning of a long, fruitful love affair with the community, which has benefited in untold ways from their contributions. Dave, a successful Tacoma attorney, contributes his wisdom and expertise to many island organizations, including two that he founded. One is Island Arts, which sponsors musical and dramatic performances such as the annual visit of the Tacoma Concert Band. The other is the Quality of Life Committee, which addresses important community issues when necessary. Jeanne (left), who directs a free weekly medical clinic in Tacoma, has served the historical society in many capacities, including as president and in her current position as director of events and community services. Dave and Jeanne are justly proud of Oro Bay Orchards, which they established on their part of the old Dahlgreen homestead in 1992. In season, they donate fruit to the Garden Market and sell many cases of their fresh pears and apples in Tacoma. They have become famous for their annual cider-pressing parties as well as their generous contributions of apples to the historical society's Cider Squeeze. Jeanne is an expert equestrian and master gardener; among Dave's many accomplishments is his climb of Mount McKinley. In recent years, they have made several trips to Africa, where they have rendered extensive volunteer service. They were chosen Man and Woman of the Year in 2012, but they do not show any signs of slowing down, thankfully! (Both, courtesy of Anderson Island Historical Society.)

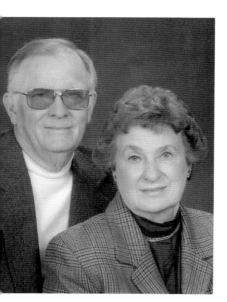 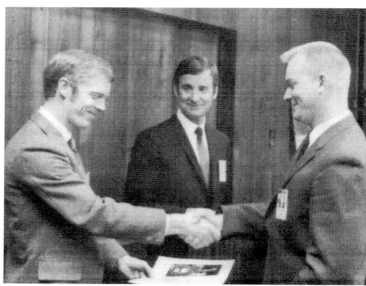

The Stephensons, Tried and True

Weekenders for more than two decades, Ed and Lucy Stephenson (left) moved permanently to the island in 2003, and it was just a matter of time before they began to participate in community life in a meaningful way. Ed had a long, successful career in aerospace engineering and management, and Lucy was executive assistant to a Boeing senior vice president. Ed was responsible for flight reliability for several Apollo command modules, including Apollo 11, which put the first men on the moon. At right, Ed (right) receives an award from astronaut Rusty Schweikart (left) at the Manned Space Center in Houston. Four decades later, Stephenson's and Schweikart's grandsons were classmates in junior high school in Seattle.

Natives of Texas, Ed and Lucy had given generously to the communities they lived in. Once they finished building and landscaping their home on the old Dahlgreen homestead, they got involved with the historical society and soon found ample outlets for their talents and energy. Ed has served multiple terms as president, chaired the steering committee, and served as project manager for the new Archival Building, while Lucy is director of archives and education and has written a number of successful grant proposals to secure funding for restoration projects. Besides serving on the Archival Building Steering Committee, she produces the island telephone book and the historical society cookbook, arranges historical programs, led the digitizing project for tracking the museum collection, and has published a much-appreciated handbook for the use of museum docents. She was responsible for overseeing several years of newsletters and communications with the membership. Ed also has served several terms with, and has chaired, the Anderson Island Community Advisory Board and worked on the Anderson Island Community Plan, in addition to his service as president of the Tanner Electric Cooperative Board of Directors and the Anderson Island Historical Society. Anderson Island is their home, sweet home! (Both, courtesy of Lucy Stephenson.)

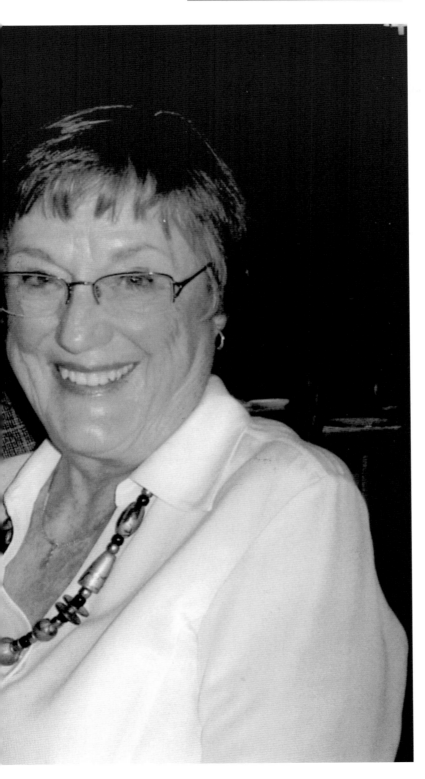

Liane Heckman, Preservationist Liane Heckman is chair of acquisitions for the historical society, with total recall of the collection, donors, and where and how artifacts are used. She designed and created the new saw museum at Johnson Farm, incorporating printed educational materials, stories, photographs, and various logging saws and tools, with a self-guided tour. The historical society photography contest, the source of many of the photographs in this book, is another of Heckman's responsibilities. She has held many positions in both the historical society and the community club and has preserved the beautiful habitat surrounding her home on Higgins Cove with a conservation easement. (Courtesy of Anderson Island Historical Society.)

Lee Schauf, Dear Santa

Raised in Seattle, Oklahoma, and Kansas, Lee Schauf also lived in Hawaii and Massachusetts before settling down in Tacoma in the 1980s. Relocating to the island turned out to be the best move he and his wife, Marianne, ever made. After retiring from his career with the Port of Tacoma, Lee got involved in island life and ended up serving as the more-or-less permanent president of the Anderson Island Association. When he has any spare time, he is almost certain to be found helping someone out with a remodeling project, fixing a piece of equipment, or taking something to a needy neighbor. One of his most unforgettable roles is serving as Santa at various holiday functions, a calling he fulfills all year, whether he is in costume or not. (Courtesy of Andy Hundis.)

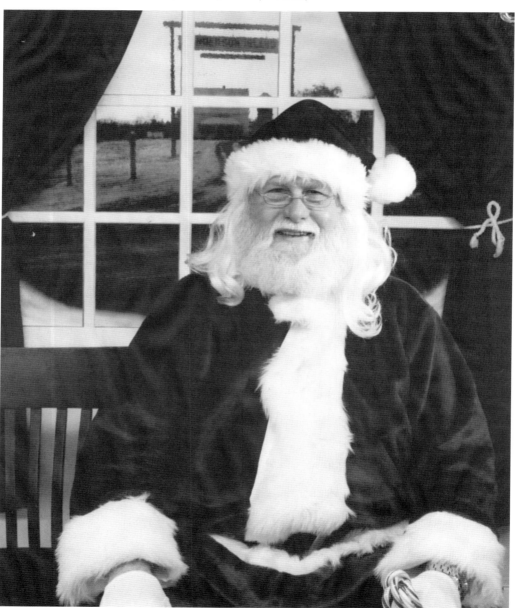

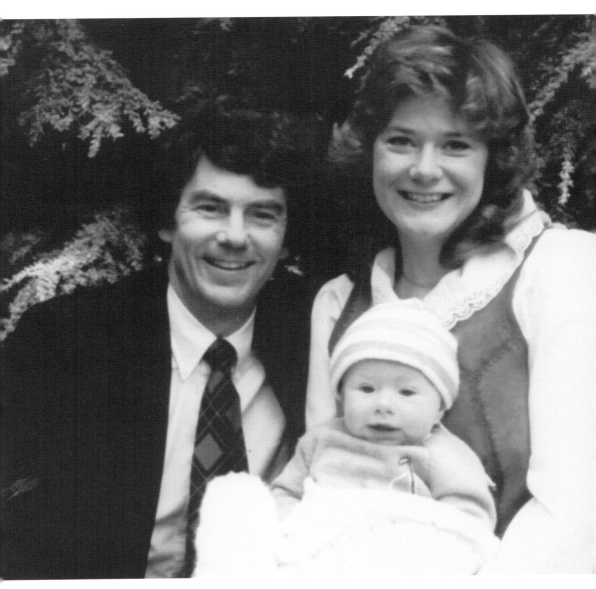

Rick and Melissa Anderson, Sinking Roots

Rick Anderson grew up in Tacoma and started coming to the island in the 1950s after his family bought the old Petterson farm on East Oro Bay. A Minnesota native, Melissa met Rick while visiting the island in 1975. Rick had answered the call to move to the island in 1972. He served as president of the historical society in its early days and soon found a place on the park board. He participated in founding the Homeowners Association (now the Island Association) and took a turn as president in the mid-1990s. Melissa, who taught in a bilingual school after a stint with the Peace Corps in Costa Rica, served as editor of the *Island Sounder* and as an EMT with the fire department. Later, she put her educational background to work teaching their children at home. Rick braved the daily commute to Tacoma for 20 years before retiring to the island full-time, when he found out what work is all about. Together, they have raised their family to love the island, enjoy music and gardening, and cherish the community. Here, Rick and Melissa are shown with baby Andreas. (Courtesy of Anderson Island Historical Society.)

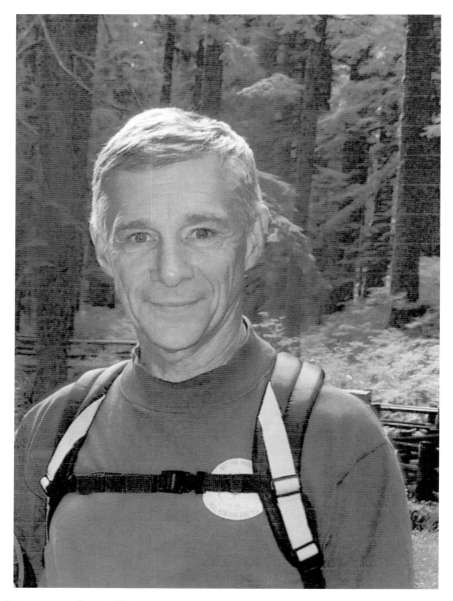

Dave Jacobsen, a Long History

From the age of six months through high school, Dave Jacobsen spent a month every summer on the island with his family. His minister father, Harold, often presided over Sunday church services and performed an occasional wedding or funeral service during their stay. With no formal church on the island at the time, services were held in the Wide Awake Hollow School. The Jacobsen family eventually sold their property. In 1970, when Dave married his wife Lynne, they honeymooned on the island. They eventually purchased property, built a home, and retired on the island. Since his retirement, Dave has volunteered his time as chairman, ferry liaison, and secretary of the Anderson Island Citizens Advisory Board, has been a park board commissioner, and has served on the Anderson Island Historical Society Board of Directors. He is currently secretary of the Anderson Island Volunteer Patrol and a member of the island American Legion, where he has served as secretary. (Courtesy of Lynne Jacobsen.)

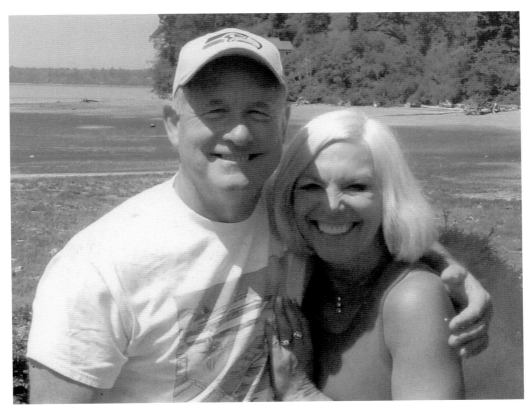

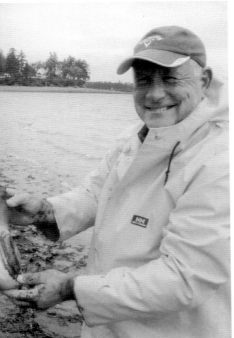

Joe and Marsha Howells, What's for Dinner?
The Howells moved to the island in 2005 and immediately began serving the community in myriad ways. Joe heads up Anderson Island Citizens Advisory Board, an organization that serves as a liaison with Pierce County regarding community needs and concerns. He is also commodore for the Anderson Island Yacht Club. One of the club's activities is decorating its boats for a parade during the star lighting at the ferry landing in early December. Rain (mostly) or shine, the festively decorated boat parade goes on. Joe and Marsha regularly volunteer for work parties and other events for the historical society. On the left, Joe is seen holding a geoduck clam that he dug from his beach.

The indefatigable Marsha's specialty is planning and organizing the food requirements and preparation for community events. Salmon and ribs for 800 people? No problem. Year-round, she arranges biweekly lunches for work-party volunteers at the Johnson Farm. Marsha takes the lead in a variety of community events. She is a gardener par excellence. (Above, courtesy of Marsha Howells; left, courtesy of Anderson Island Historical Society.)

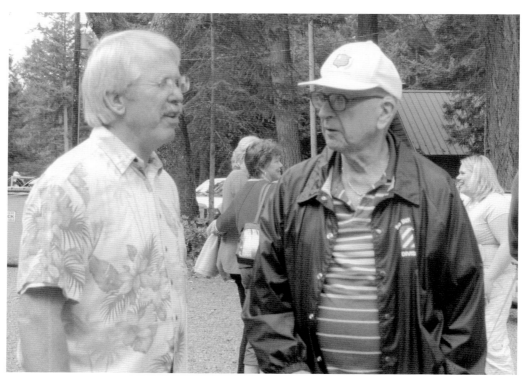

Jay and Trina Wiggins, Always Ready

In 1980, Jay and Trina Wiggins (below) moved to Anderson Island and became integral parts of the community. For some years, Jay worked for local builders and operated a successful chimney-sweep business. He joined the volunteer fire department, never dreaming that he would one day become the assistant chief. Jay (above, left) and former chief Morris Krepky (above, right) always enjoyed talking about department business.

Jay tends to work quietly in the background, but he is always a willing helper in Trina's volunteer projects. Through their business, Shelter Construction, Jay has done many remodels and installed numerous septic systems on the island. Trina's first volunteer meeting took place just a week into her island residency. She has not stopped volunteering since. She has been the president and vice president of the Anderson Island Community Club and served as chairman of the Island Fair for many years. Trina's deep love for children has kept her involved with the school booster club, her church youth groups, and Young Life. Jay and Trina have raised many foster children besides their own four, providing a loving home and support to help equip them for life. (Above, courtesy of Anderson Island Historical Society; right, courtesy of Trina Wiggins.)

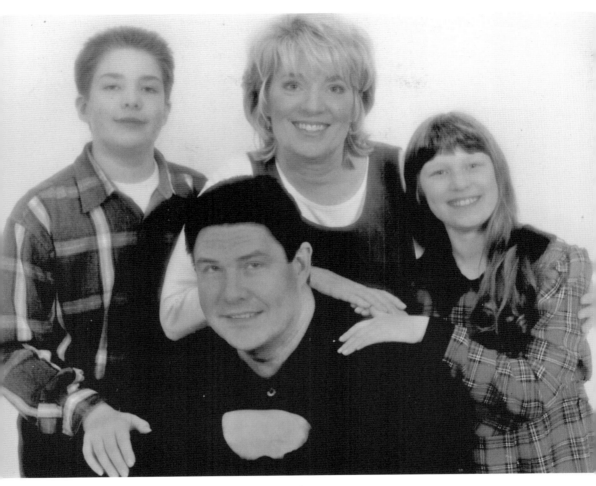

Steve and Kelly Wolffe, Christian Fellowship
The Wolffes came to Anderson Island in 2002 to pastor Anderson Island Christian Fellowship. Steve was born in Spokane and grew up in California. He served as a medic in the Air Force and was senior pastor at Cottage Grove Living Faith Christian Fellowship before coming to the island. He is active with the Anderson Island Fire Department and serves as its EMS officer and chaplain. Kelly, born and raised in California, earned her bachelor's degree at the University of the Pacific Conservatory of Music. She serves as the music director of the fellowship. She educated both of their children at home, from kindergarten to high school. Their son Gabriel (left) is studying mechanical engineering at St. Martins University, and daughter Natalie (right) is a published children's book illustrator living on the island. (Courtesy of Kelly Wolffe.)

Chuck Cunningham, a Fighter

Chuck Cunningham grew up in Tampa, Florida, and earned degrees in aeronautical engineering from Parks College and Georgia Tech. He worked in the space industry for several companies before retiring from Pacific Nuclear Systems in 1994. He and his wife, Genie, bought an old farm on Oro Bay in 1970 and moved there full-time in 1992. Chuck became an active member of the community, serving as president of the Homeowners (now Island) Association, a park board member, and a fire commissioner, as well as an EMT with the fire department. He always contested vigorously for what he believed was right, as evidenced by his two-year effort to get the permits to build a boathouse on his property, a feat that may never be duplicated! (Courtesy of Genie Cunningham.)

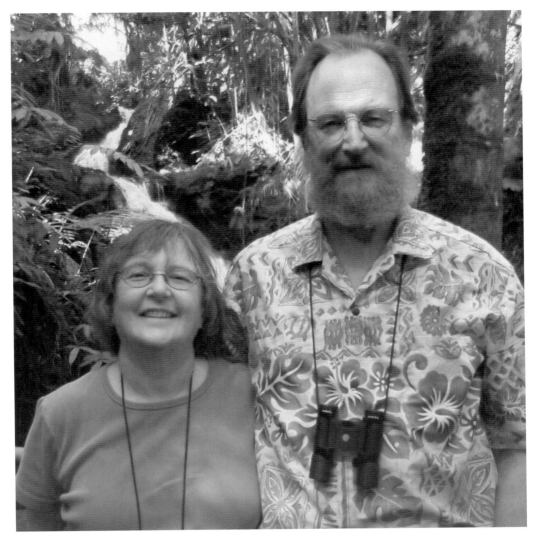

Evans and Carol Paschal, Many Hats

Evans and Carol Paschal met in college, but waited 30 years after their first date to marry. Carol grew up in Walla Walla, and Evans in Issaquah. He received his PhD in electrical engineering from Stanford, while she earned a BA in Oriental languages and an MBA from the University of Washington. An expert in the design and operation of antennas, Evans has made over 20 trips to Antarctica, some involving stays of over a year. Carol tried a back-to-the-land lifestyle and found that she preferred a career in accounting, retiring from her day job and moving to Anderson Island in 2001. Evans continued his research and consulting career, meanwhile presenting programs about his time in the Antarctic and organizing a choral group on the island. Carol started and maintained a growing operation, Island Flowers, for several years, and joined the group Not Quite Right as a fiddler and vocalist. She was a member of Anderson Island Citizens Advisory Board (AICAB) and has served as secretary of the historical society, treasurer of the Anderson Island Association, and chairman and treasurer of the park board. Since 2007, she has directed the Summer Nature Camp, focusing on getting young people involved in the island marine environment and salmon-recovery efforts. Carol is also a member of the advisory committee for the Nisqually Reach Aquatic Reserve. (Courtesy of Evans Paschal.)

Terry and Michal Sleight, Island Indispensables

Michal, or "Mikey," as she is known, in many ways grew up on Anderson Island, despite attending school in Burien, Washington. When she began coming to the island in the early 1950s, the population sign read "61," until, one day, the "1" was crossed out and a hand-written "2" added. She has lifelong friends among the island pioneer families and their offspring. Her parents and some of their Burien relatives and neighbors purchased a parcel of land on the north of the island and eagerly visited on the weekends. This part of the island is known as "Little Burien." Mikey's mother did not drive, so Mikey learned to drive at age 10. Some years later, she realized that being taught to drive at that young age allowed her dad to continue fishing, while keeping her mother happy. She proudly taxied her mother on the few (and challenging) roads to visit her island friends.

Mikey and Terry Sleight, both retired now, devote endless hours to assist friends in need and volunteer extensive time with the Anderson Island Historical Society. Terry is an expert on all things required to keep this historic farm operating and in good order. He was instrumental in the Johnson Farm barn being added to the Washington State Department of Archaeology and Historic Preservation Historic Barn Register and was interviewed by the media. He leads weekly volunteer work parties that set up for events and maintain, repair, and restore the facility, always keeping the historical society's mission statement in mind. Mikey has led many projects to reorganize and refurbish areas, providing increased efficiency and cost savings. She is the go-to person for problem solving and helping, and keeps the old advertising slogan "Let's get Mikey" familiar on the island. (Courtesy of Michal Sleight.)

Russell Cammon, Native Son

Russell Cammon was the grandson of pioneers of Anderson and McNeil Islands, all of Scandinavian extraction. His mother, Bessie, the author of *Island Memoir*, instilled in him a deep love of the island and its people. Russell and his two brothers, Robert and Roger, had a sister, Anna, who died before Russ was born. He had many adventures as a young man, fishing, playing in the woods, and attending the island school. In 1940, he and his brothers created an airport and built their own airplane. A few days before his 19th birthday, Russ took off in the plane, and the engine failed. Miraculously, he survived the ensuing crash, but ended up spending over a month in the hospital. Russ served in the US Army from 1943 to 1946, including a tour of duty in Europe. After his discharge, he attended college in Bellingham, where he met Jane Smart. They were married and graduated together in 1950, soon making their home on the island to raise their three children. For a while, Russ and his brother ran a sawmill on Otso Point. He was employed as a mechanical service relief officer at the McNeil Island Penitentiary from 1956 to 1976. Russ lived a very happy and productive life in "retirement." He was a member of the school board, a founding member of the Anderson Island Park and Recreation District, one of the first members of the fire department, and an active member of the Community Church. When the Anderson Island Historical Society was founded in 1975, Russ served as its first president. He enjoyed watching the tugboats, painting, keeping cats, and solving the world's problems over coffee with friends. Russ was a wonderful father and husband, and a keen student of Anderson Island history. (Courtesy of Anderson Island Historical Society.)

Chuck Hinds, Ironman

Chuck Hinds grew up in Pennsylvania and attended a one-year program in welding technology at Beaver County Community College after graduating from high school. In 1968, he entered the Army and, within nine months, was in Vietnam in a mechanized infantry unit. Later, he attended Penn State for a few semesters before he met and married Kelly, shown with him below. He rejoined the Army and was assigned to a mechanized infantry unit at Fort Lewis and also worked at the base forestry office for a year. Once out of the Army, Chuck went back to school at Saint Martin's College, where he earned a BS in civil engineering, a BA in sociology, and a master's in engineering management. Chuck worked for Washington State at the Departments of Transportation (two years), Fisheries (six years), and Ecology (twenty-two years). He also received a commission in the Navy reserves and spent 28 years in the Civil Engineer Corps and Seabees, retiring as a commander. Chuck and Kelly moved to Anderson Island in 1999, and both have been very active in the community. Early on, he was appointed to the newly formed AICAB. He has served as chairman of the park board and directed the Salmon Recovery Project on Schoolhouse Creek. In his spare time, he has trained for and finished four Ironman triathlons, led kayak expeditions, and helped many people build their homes. (Courtesy of Chuck Hinds.)

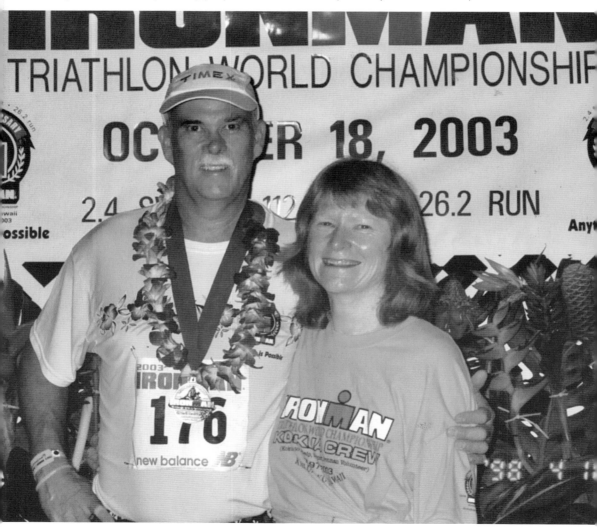

Judy Adams, Caring Ways

In 1968, Judy Adams and her family moved into their newly purchased Anderson Island home. Word quickly spread that Judy was a registered nurse, and her skills were put to work by many locals. As many of the medical needs were emergency in nature, Judy honed her skills with EMT and paramedic training. Recognizing the need for airlifting patients off the island, she coordinated with the local military base, and an agreement was reached. The military would use emergency airlift evacuations from the island "ball field" as training missions. Judy and a friend opened the island's first drive-in restaurant, where many young islanders enjoyed their first job. The drive-in is long gone, but it is not forgotten. Private enterprise has taken over the airlift evacuation. Judy's kind and caring ways live on and are still remembered by many. (Courtesy of Judy Adams.)

Martha Smith, Always Serving

Moving from her home in Vancouver, Washington, to Anderson Island in 1984, Martha Smith, shown here with her husband, Bob, immediately began serving. She organized a reading club, the first children's summer day camp, and a parade to kick off the annual Anderson Island Community Club Fair. She created scholarships for graduating seniors, served as president of the Anderson Island Community Club, chaired the Anderson Island Park and Recreation District Board of Directors, and was the first woman president of the Riviera Community Club Board of Directors. Smith served from 1977 to 1990 and also edited Riviera's monthly newsletter. She personally welcomed every new island resident during her tenure. In 1992, she was honored when the community selected her as Woman of the Year. In 2002, Smith was again honored when the Riviera Community Club named their new activities room the Martha Smith Room. She returned to Vancouver in 2004 to be nearer family, but she will never be forgotten for always serving Anderson Island's residents. (Courtesy of Anderson Island Historical Society.)

CHAPTER FOUR

Builders

The first requirement for a stay of any length on Anderson Island has naturally been shelter. The earliest settlers built cabins or sheds from the native Douglas fir or cedar, using not much more than an ax. Often, these structures were abandoned as their builders vacated the island or moved to new claims, only to be occupied by new arrivals needing protection from the elements while they worked their own land. With time and success, proper homes, constructed with milled lumber and real windows, began to appear, built primarily by their owners, often testifying to skills acquired in the old country. Several early houses from the 1880s and 1890s survive to this day, attracting the interest and appreciation of visiting architectural historians from Sweden and Finland, who marvel at their faithful replication of the farmhouses in Småland and other regions of Scandinavia.

Much of the island's impressive old-growth timber was logged off and rafted to mills around Puget Sound, but, here and there, a sawmill appeared on the island and turned out a satisfactory product. In the 1890s, a brickyard flourished on Jacobs Point for a few short years, helping to fuel Tacoma's and Seattle's boom in brick construction following the devastating Seattle fire of 1889. The 20th century saw the advent of professional tradesmen and builders/contractors. Thus, Pete Anderson made a name for himself as a framer, and John Johnson and his son John Jr. plied their trade as masons and plasterers for half a century. Bob Ehricke began providing concrete for footings and basements after World War II, while his carpenter brother-in-law Lowell Johnson built most of the new homes on the island between 1950 and 1975. By the early years of the 21st century, demand had grown to the point where half a dozen island builders found it possible to make a living. Throughout the years, the main challenge facing any aspiring builder or would-be homeowner on the island has been the extra effort and cost of importing supplies and building materials. Many have met this and other challenges with determination and ingenuity, as this chapter will demonstrate.

Nels Magnus Petterson, Pioneer Builder

The first recorded professional builder on Anderson Island was Nels Magnus Petterson, who moved to the island with his wife, Anna, and three of their children in 1882. In 1883, as reported by Bessie Cammon in *Island Memoir*, Petterson was paid $600 for building a schoolhouse. Measuring about 16 feet by 26 feet, the new building was constructed of rough twelve-inch boards and four-inch battens, at a cost of less than $1.50 per square foot. It stood at approximately the location of the current Wide Awake Hollow, until the present building replaced it in 1905–1906. Petterson and his family left the island for a few years, returning in the early 1890s to build a permanent home on East Oro Bay. Present-day architectural historians admire the classical Småland features of the house and surmise that Petterson acquired his building skills in his native Sweden. Pictured from left to right are Anna, Nels, and Carl Petterson. (Courtesy of Cindy Ehricke Haugen.)

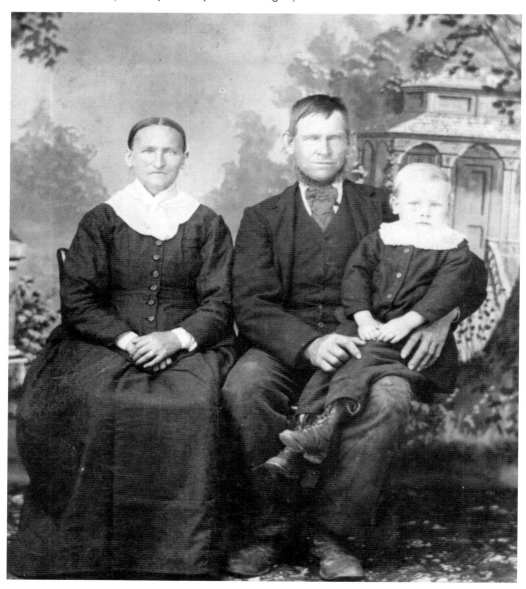

Pete Anderson, Island Carpenter

Pete Anderson, a bachelor, came to the island in 1923 when requested by the Erik Andersons to help with some carpentry at their home on Oro Bay. He continued to live and work much of the time on the island—building, finishing, remodeling homes, doing boat repairs, and constructing chicken houses. When his health began to fail, Anderson moved to a nursing home in Tacoma. The Erik Anderson family took care of him to the end, always referring to him as "a Godsend to Anderson Island." (Courtesy of Anderson Island Historical Society.)

Bob Ehricke, a Born Builder

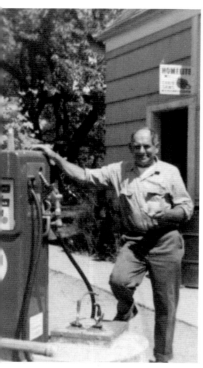

Born and raised on the island, Bob Ehricke was always a builder. In elementary school, he and friends decided they should build a fort to gather in during recesses. Days of planning went into this creation. It would be in the center of Wide Awake Hollow School's firewood shed. As winter set in, the school's firewood supply started diminishing. One day, a fort wall was breached when the schoolmarm was replenishing the firewood supply. The locals donated wood to keep the school warm through the winter, but that would be the last fort built at the school. Ehricke joined the Army after receiving his mechanical engineering degree and served in the South Pacific and on Attu Island. When he returned home, he started a successful gas station, mechanical garage, and construction company.

Ehricke's workshop itself was an engineering feat. Built by Pete Anderson, it was an immaculate, large, three-bay garage. Along the high ceiling ran a network of pulleys and gears that connected to various machines with wide leather belts, all powered by a generator. Power did not come to the island until 1961. Bob could repair automobiles, boats, and farm equipment, put in a septic system, or build a house. He once restored a boat that had spent many years at the bottom of Puget Sound and built an organ for his own home. Shown below are, from left to right, Ellen Ehricke, Ernest Alfred Ehricke, Ernest Robert "Bob" Ehricke, and Ernest August Ehricke. (Left, courtesy of Terry Bibby; below, courtesy of Carol Shearn.)

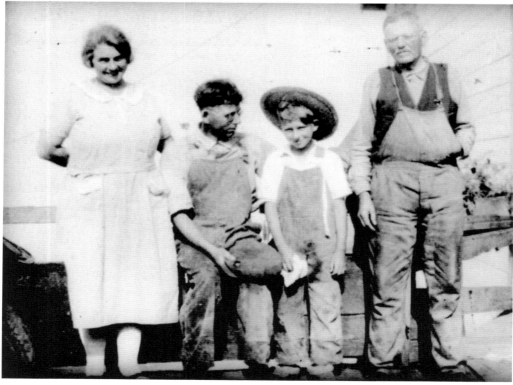

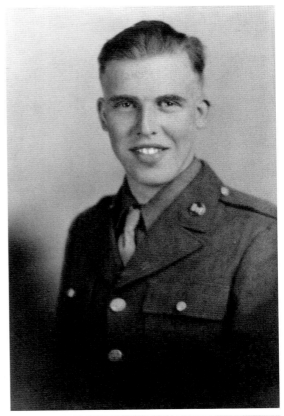

Lowell Johnson, Premier Builder

Lowell Johnson, a great-grandson of Nels Magnus and Anna Petterson, was born on the island in 1925. He attended the island school and graduated from high school in Tacoma. There, he picked up skills that served him well when he became the island contractor. He served a hitch in the Army before returning to the island, where he tried his hand at raising cattle. According to relatives, Johnson was quite the eligible bachelor for a long time. He eventually turned to carpentry and made a good living building houses on the island. Between 1950 and 1977, practically every new house on the island was built by Lowell Johnson, along with many repairs. In 1965, Lowell married Marjorie Larsen, a widow who was living in Port Orchard. She moved to the island, and Lowell helped raise her five children.

Lowell was a staunch member of the community. He was one of the original members of the park board and was chairman at the time he died suddenly in 1977, only 51 years old. (Top, courtesy of Cindy Ehricke Haugen; bottom, courtesy of Terry Bibby.)

Tom White, Getting It Done

After graduating from high school and attending community college, Tom White pursued life as a commercial fisherman aboard his boat *School Boy*, so named by his fellow fishermen. He loved the sea and marine life and spent some time diving off the Texas Gulf Coast. Enlisting in the Army, he attended officer candidate school and flight school, then served as a pilot during the Vietnam conflict. While stationed at Fort Lewis in Tacoma, he discovered nearby Anderson Island, purchased property, built a home, and took up residency with his family. After leaving the Army, he returned to college and received a degree in marine biology. White was an EMT for the Anderson Island Volunteer Fire Department. In 1975, he purchased Bob Ehricke's construction company, built homes, and did site preparation for many years. White loved the island's "widow ladies." A call for help, day or night, would send him scurrying to repair their broken pipes, clogged plumbing, and other problems. For many years, he was on the Steilacoom Historical School District Board and student-taught for the Steilacoom School District. White often brought large groups of students to his beach to share his marine knowledge. He retrieved salmon eggs from the Washington State Fisheries and taught the Anderson Island schoolchildren how to care for them until hatching. The fingerlings were released into School House Creek, which he had meticulously cleared of blocking trees and brush. The tradition continues today, and the salmon population continues to grow because of his efforts. Tom White passed away in 2004, but he will never be forgotten. Both Tom White Park and Tom's Park are named in his honor. (Main image, courtesy of Jeanne White; inset, courtesy of Anderson Island Historical Society.)

John Larsen, Oro Bay Homes

John Larsen moved to Anderson Island when his mother, Marjorie, married Lowell Johnson in 1966. John quickly learned about construction from his stepfather, who was for many years Anderson Island's leading builder. After serving a stint in the US Air Force, Larsen worked for Johnson before earning a degree in environmental studies from Evergreen State College. He and his brother Paul built houses together on the island for a dozen years, until he went to work in the construction and maintenance division of the Washington State Patrol in the 1990s. John established Oro Bay Homes in 1998 and has been busy crafting cabinets, doing remodels, and building premium-quality homes ever since. (Courtesy of Aidan Avey.)

Paul and Bridget Larsen, Larsen Construction

Paul Larsen got his start in construction as a teenager working for his stepfather, Lowell Johnson. He recalls doing a lot of cleanup and hauling lumber. He started working full-time for Johnson about the time he passed away unexpectedly in 1978. With the help of Johnson's brother-in-law, Bob Ehricke, Larsen took over the business. Soon, he was joined by his brother John, and together, they formed Larsen Brothers Construction. Paul and his wife, Bridget, started Larsen Construction in 1989, and since then, they have been building custom houses and additions and doing remodeling on Anderson Island. (Courtesy of Bridget Larsen.)

Doug Emerick, Maintaining Island Necessities

A builder and mechanic from a young age, Doug Emerick was delighted when his high school mechanics teacher, Tom White, asked him to work the summer for his construction company on Anderson Island. Emerick made the daily trip to the island in his go-cart. Only once was he stopped by the local policeman, who only asked that he wear his helmet. Emerick continued working as White's mechanic throughout high school. Upon graduation, he began working full time. White became very ill when Emerick was 21, and Emerick was asked if he wanted to buy the company. It was an opportunity he could not refuse. Doug Emerick continues operating White's, building, remodeling, and doing mechanical work and site development. (Courtesy of Doug Emerick.)

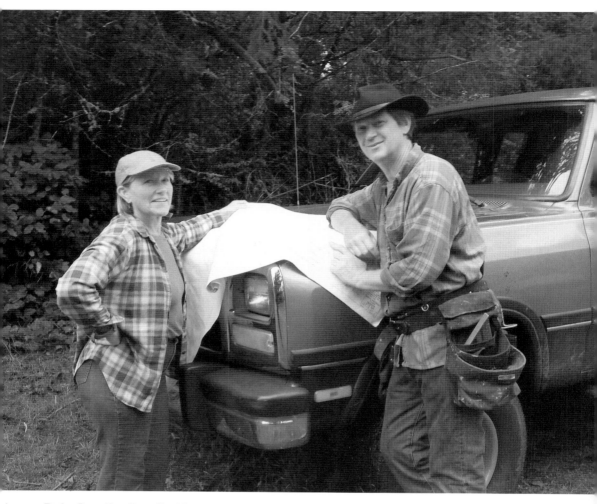

Dale Goodin, Goodin Homes

Dale Goodin (right) started Goodin Homes in Oklahoma, but moved to Washington in 1986. His family had been visiting relatives on Anderson Island for years. He built custom and spec homes and subcontracted to do framing and siding in Pierce County, where building was booming. At one time, he had up to nine employees. His first Anderson Island project was to build a home for his parents in 1988. In 1997, he moved his family to the island and began building in earnest what he calls dream homes for his island customers. Co Rogan (left) joined the company in 2010. In 2011, Goodin Homes was selected to be the maintenance contractor for the Anderson Island Park District's system of parks and recreation facilities. (Courtesy of Dale Goodin.)

Chuck Horjes, Chuck Horjes Construction

The Horjes family bought the Old Ekenstam homestead in the 1930s, so Chuck Horjes grew up spending weekends and summers on the island. While still in his teens, he began working on the purse seiner *Memories*. After graduating from Wilson High School, he joined the US Navy and served on a guided-missile cruiser. He began in construction in the early 1980s and started Chuck Horjes Construction in 1985. His work has taken him all over the state of Washington. Over the years, he has built numerous homes on Anderson Island and installed countless foundations and septic systems, along with clearing lots and logging many properties. In 2010, Horjes purchased *Memories* and has continued to fish commercially around Puget Sound and the San Juan Islands. Next stop, Alaska! (Courtesy of Chuck Horjes.)

Phil and Karen Vickers, Island Nursery

With her Larsen brothers, Karen Vickers first came to the island when her mother, Marge, married Lowell Johnson. Phil and Karen moved to the island in 1987, working many jobs before establishing Island Nursery in 1991. They constructed an impressive building next to the Island Store where they maintained an office and a retail outlet. For years, Karen has done the office work and driven the dump truck to supply garden and landscape materials to the island, while Phil has done general construction work and operated heavy equipment. Their projects include site preparation, roadwork, hardscapes, landscaping, and septic system installation. (Courtesy of Karen Vickers.)

CHAPTER FIVE

Artists

It might, with some justification, be said that art is a byproduct of leisure, in the sense that artistic expression takes a backseat to the struggle for survival. Hence, the pioneers of Anderson Island seem to have had little time to produce art. This was left to their successors, the second and third generation of islanders, and, in recent years, to a few professional artists and retirees. Notable among the earliest island artists are the photographer William Ekenstam, who seems to have considered every island gathering an opportunity to practice his avocation, and Al Ravnum, an expert wood carver. Like them, Nels Warner, an all-around handyman and an excellent oil painter, seems to have been self-taught and given to making presents of his works rather than selling them. The islanders have responded enthusiastically over the years to art classes offered by seasoned artists such as B. Anderson, Lynne Jacobsen, and Alexei Antonov. Quilting and other arts and crafts have enjoyed a renaissance among the mostly retired community, culminating in the eagerly anticipated quilt raffle at the annual Island Fair; the Quilts of Valor, which honor the nation's veterans; and a successful bazaar in conjunction with the holidays at year's end. Several well-trained painters, potters, and sculptors have chosen to make their homes on the island over the years, often finding inspiration in the island's wildlife, flora, and maritime setting. Proof of an abundance of local talent is increasingly found at the Island Fair and in an annual art show held at the Martha Smith Room.

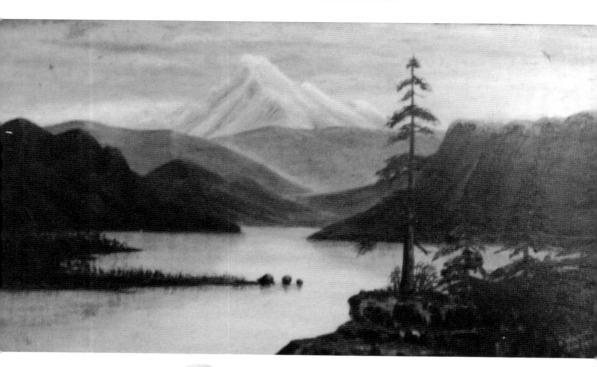

Nels and Martha Warner, "Buildt by"

The Warners moved to the island in 1908. They were well known for their contributions to the community, Martha serving as president of the Anderson Island Community Club and Nels an all-around handyman. The clubhouse's big stone fireplace is adorned with a brass plaque that reads, "Buildt by Nels Warner," a testimony to his craftsmanship and his thick Norwegian accent. He is the first known artist to live on Anderson Island. Many island homes were decorated with Nels's oil paintings, mostly of landscapes and seascapes, such as the one shown above, which is on display at Johnson Farm. (Both, courtesy of Gordon S. Warner.)

Bettymae Anderson, an Artistic Life

Bettymae Anderson, better known as B. Anderson, was born and raised in Wenatchee, Washington. She attended Whitman College, where she majored in history and theater. Having a lifelong love affair with art, she subsequently attended Pasadena City College and Otis Art Institute, which lead to an acclaimed career in design, printmaking, painting, and textiles. She opened her own art school and studio in South Pasadena, touching the lives of hundreds of young and adult artists. When B. and her husband, Randy Anderson, moved back to Anderson Island in the 1970s, she played a leading role in the founding of the Anderson Island Historical Society and its museum store and worked tirelessly in the community to promote history, art, and preservation. Her drawing, painting, and weaving classes attracted many of the island's senior citizens, whose latent talents were drawn out and nurtured by her enthusiastic teaching skills. Her love for renovating historic buildings resulted in the award-winning Anderson House bed-and-breakfast at Oro Bay. The numerous creative retreats and writers' workshops held there established her as a cook and author. Since her passing in 2007, time has not lessened the esteem of her fellow islanders for an amazing life lived artistically. (Both, courtesy of Randy Anderson.)

Ed Falkenberg, Sculptor

Ed Falkenberg, a retired engineer, moved to the island in the 1960s and began exploring his passion for art and gardening. His abstract sculptures, many of animals and birds, were carved out of various kinds of hardwood and subsequently cast in bronze. They convey a lifelike quality that is unusual in abstract sculpture. A wonderful storyteller, Falkenberg participated in many community activities and was a great contributor in the early days of the Anderson Island Historical Society. (Courtesy of Anderson Island Historical Society.)

Al Ravnum, Born Whittler

Al Ravnum and his father bought lots near Amsterdam Bay in 1914, thinking it was a good place to moor their fishing boat. Al eventually moved to the island and spent his last years in retirement here, enjoying the woods and beaches and indulging his bent for sketching and whittling. Many of his carvings display remarkable virtuosity, including chains and toys with moving parts made from a single block of wood. (Courtesy of Anderson Island Historical Society.)

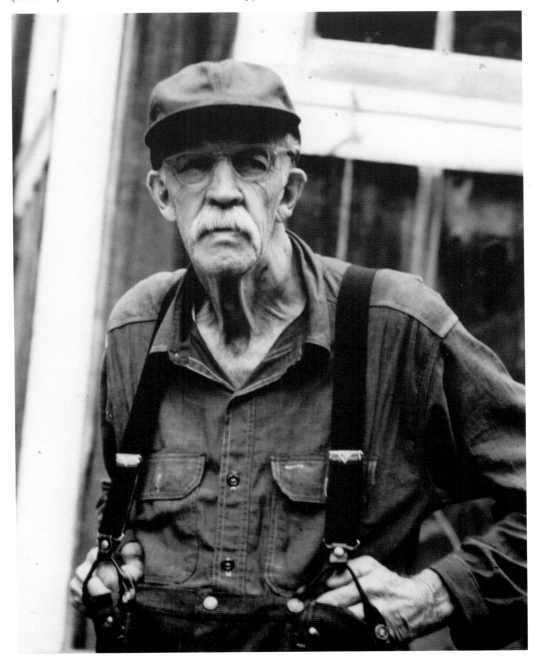

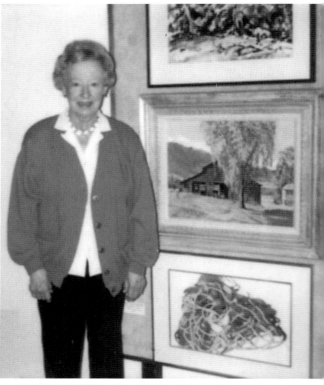

Virginia Garrett, Island Painter
Virginia "Ginna" Garrett grew up in Spokane and earned a fine arts degree from the University of Washington. Later, she studied under several prominent Northwest instructors and artists. She won many awards in regional art shows, displaying and selling her paintings in several local galleries. She and her husband, John, built a home at Cole Point on Anderson Island in 1973. John retired from Foss Tug Company in 1977, and they became full-time residents of the island in 1979. Early on, Ginna painted mostly in oil or acrylics, but, in later years, an allergy to paint thinner forced a change to watercolor. Ginna enjoyed painting island subjects including buildings, boats, and landscapes. (Courtesy of Chuck Garrett.)

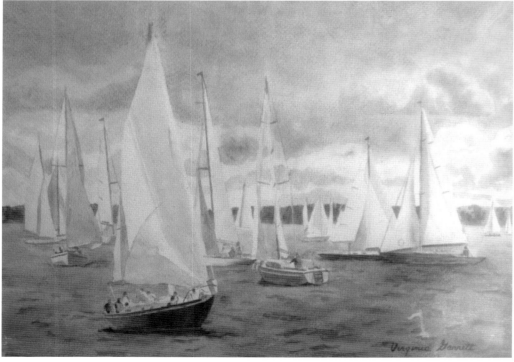

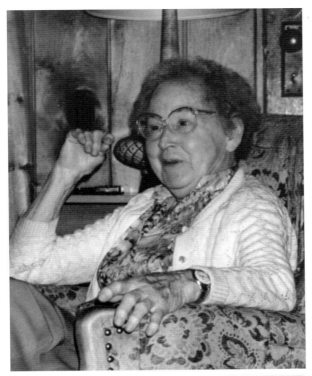

Billy Hansen, a Late Bloomer
Lucille "Billy" Hansen moved to the island in the 1950s when her husband, Harold, took the job of captaining the ferryboat *Tahoma*. A sweet and gentle lady with a wonderful green thumb, Billy's dream of becoming an artist became a reality when she began taking lessons from her island neighbor, B. Anderson. Billy painted and drew boats, barns, and landscapes. As her skills developed, her real forte became flowers. (Both, courtesy of Anderson Island Historical Society.)

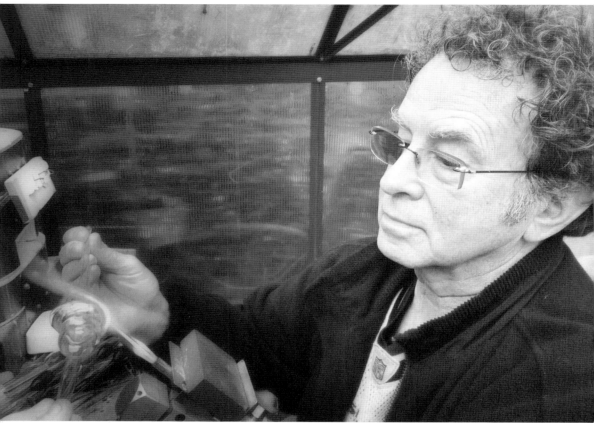

Bob and Karen Wilson, an Artful Team

The Wilsons moved to the island in the mid-1990s. They had lived in Tacoma for many years, where Bob had a successful medical practice and Karen was considered a master teacher. Once on the island, they established a promising vineyard and an exquisite bed-and-breakfast. In their spare time, Bob (above) built rustic furniture from the trees on their land, including cutting and planing the wood at the island's primitive sawmill. He has become an expert in blowing glass, while Karen (left) continually gets her hands dirty in her extensive garden and by throwing pottery. She also fashions jewelry using Bob's creations. Bob has gained a reputation as a kind of musical tramp, willing to sing and play bass, harmonica, mandolin, or percussion in any band that will have him. Just to be on the safe side, though, he has kept his day job as a physician. (Both, courtesy of Karen Wilson.)

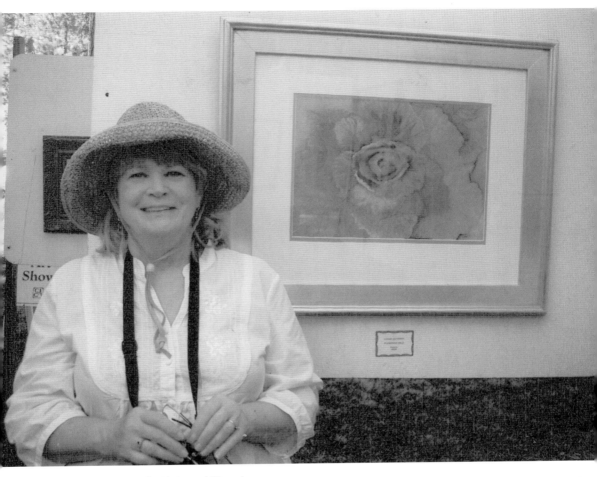

Lynne Jacobsen, Artist and Teacher

Raised in Spokane, Washington, Lynne Jacobsen has drawn and painted as long as she can remember. She earned her degree in art at Eastern Washington University and later went back to school to get a nursing degree. She continued to paint and draw throughout her nursing career, taking a break to fulfill a longtime dream of joining the Peace Corps in 1996 and serving as a medical instructor in Turkmenistan. There, she found herself doing a lot of drawing and painting—journals in color, interesting sights—and using her art in her teaching. After retiring in 2008, she was finally able to spend the time she wanted with her art. Her work has been shown in numerous venues and has won several awards. Jacobsen's artwork takes many forms: pastels, watercolors, and oils. Dozens of aspiring island artists have honed their skills through the art classes she has offered at the museum. (Courtesy of Lynne Jacobsen.)

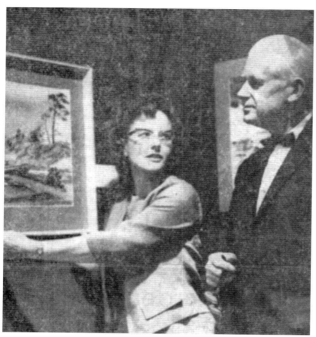

Lorraine Phillips, Painter

Her career as an artist was launched when Lorraine Phillips's second-grade teacher raved about the animated qualities of her drawing of a chicken. She and her husband, Bill (left), also an artist, bought a place on the island in the late 1950s. Throughout a 35-year career as a nurse anesthetist, Lorraine never gave up her art. She rarely went anywhere without taking along her watercolor paints and brushes. As a consequence, she produced many fine paintings of island scenes. Lorraine traveled to many countries and often taught painting aboard cruise ships. *The Barn that Was* (below) portrays Rupert Burg's barn, a notable landmark until it blew down in a recent windstorm. (Left, courtesy of Marilyn Brown; below, courtesy of Rick Anderson.)

Roger Russell, Renaissance Man

Roger Russell grew up in Minnesota and, at a young age, signed on with the Ice Capades, touring the country until he was drafted into the Korean War. On his way to Korea, he went through Tacoma, Washington, where his bus passed a man mowing his lawn in November. Russell decided that was the place for him. After serving as a forward observer in Korea, he returned to the Pacific Northwest, where he taught ice skating and ballet for years. In the 1960s, he discovered Anderson Island through a friend who owned an old farm, and Russell eventually moved to the island, living in a remodeled chicken coop. He tried his hand at many things, and succeeded at most. He built harpsichords, made a violin, grew flowers, did sculpture and ceramics, painted, wrote a piano concerto, and repaired musical instruments and equipment of all sorts. When Russell moved to the old Lindstrom house on Amsterdam Bay, he serenaded his neighbors on a carillon of his construction every evening at 7:00. At the end of his life, when he was stricken with cancer, a group of island friends provided around-the-clock hospice so he could spend his final weeks on Anderson Island. (Courtesy of Anderson Island Historical Society.)

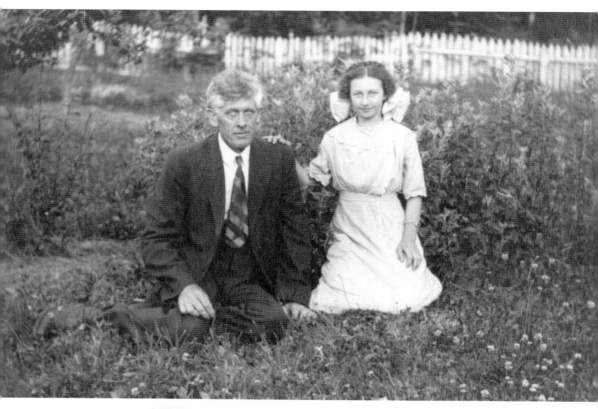

William Ekenstam, Recording Island History

The eighth of John P. and Ann Ekenstam's nine children who survived infancy, William Ekenstam was born in Sweden in 1869. He came to the island with his family in 1877 and quickly adapted to his new home. In due time, his parents passed away, and William bought property on Villa Beach. There he built, as Bessie Cammon put it, a "neat four-room house," later the home of the Ehrickes and the Whites. Ekenstam's artistic flair found its expression in photography. Wherever he went, according to Bessie, he took his camera along and photographed the doings. Picnics, Christmas parties, Sunday dinners—Ekenstam was a welcome figure at every occasion, and hundreds of his photographs have survived to document life on the island in the early 20th century. He developed and printed his own photographs and was generous in sharing his work with his neighbors. As a modern-day grandniece noted, he seems to have had a special calling for taking photographs of pretty girls in flower gardens. The above photograph is a self-portrait he took with Mary Rieherd around 1910. He died in 1913. (Both, courtesy of Dianne Avey.)

Alexei Antonov, Young Master
Born in the Soviet Union in 1957, Alexei Antonov studied at the State Art College in Baku, where impressionistic, realistic, and abstract painting were taught. From 1976 to 1990, he lived in Moscow and worked as a graphic artist and illustrator on magazines and posters. During this time, he studied the technique of the old masters, such as Rubens and Van Dyke. He left Russia for the first time in 1988, visiting Italy to study paintings in museums and to exhibit some of his own. In 1989, he opened Rubens Gallery in Moscow. He immigrated to the United States in 1990 and moved to Anderson Island in 1998. Antonov has developed to near perfection and teaches a unique classical technique practiced by few modern artists. His still-lifes and portraits may be found in homes and galleries around the world. (Courtesy of Alexei Antonov.)

Wanda Britts's Easel

With small children at home, Wanda Britts used their fireplace mantel as her easel. So gifted is she that, when looking at the oil painting shown at top, one can almost hear the rustle of leather on the horses' backs and the shuffling of their hooves. Britts paints scenes she likes and does not have a favorite style of art. She paints for her own enjoyment and does not sell her paintings, but is occasionally persuaded to display her work at art shows, where they are greatly admired and awarded.

A consummate gardener, Britts writes articles for island organizations, and also composes poetry. She and her husband, Gean, moved to the island in 1998. They have been active members and officers in the historical society and community club. Gean, an engineer, has his own art project—in three dimensions. He is presently building a robot that someday will be swooping over their beautiful backyard. (Top, courtesy of Wanda Britts; bottom, courtesy of Anderson Island Historical Society.)

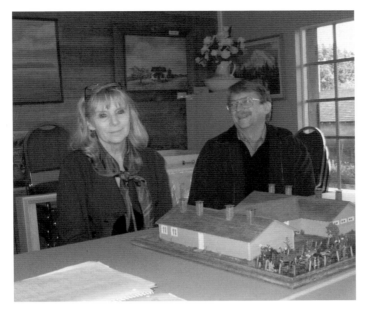

Rosemary Zilmer, Dimensional Artist

Rosemary Zilmer spent much of her youth enjoying her parents' summer home on Anderson Island. She and her husband, Mark (above), a retired surgeon, are now full-time residents and have been inspired by their love for the island and the community. Rosemary's artwork includes commercial graphic design and fine art in pen and ink, watercolor, acrylic, and oil. For a number of years, she has worked in a special medium she describes as "dimensional art" and has gained a national reputation for her museum-quality scaled "miniatures." Mark has recently added his artistic and architectural skills to this medium and, together, they have completed impressive scale renditions of the new Archival Storage Building at Johnson Farm and of Carlson's Store as it looked in the 1930s. When Lyle Carlson saw the unveiling of the model of his store, it was a touching moment that Rosemary was able to capture (below), as Carlson contemplated the work she and Mark had reconstructed in such amazing detail. Islanders who have seen it have had the same reaction—a precious moment in time has been preserved. (Above, courtesy of Anderson Island Historical Society; right, courtesy of Rosemary Zilmer.)

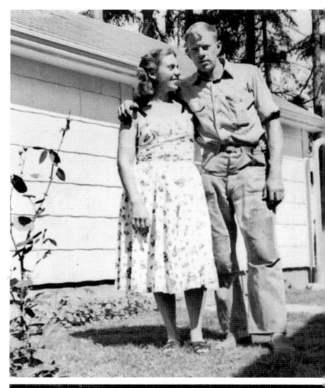

Jane Cammon, One Smart Lady

Jane Smart was born in Iowa, but she met Russell Cammon at Western Washington College in Bellingham, and they were married in 1950. Jane and Russ (top) soon made their home on the island, and Jane, an elementary school teacher, taught grades one through six at Wide Awake Hollow, the Anderson Island school. She was a very creative person and is especially known for the wonderful stuffed animals and dolls she made. For many years, Jane contributed her creations to the Anderson Island Community Club, to be raffled at the Anderson Island Fair, always a popular event. Some of Jane's dolls are on exhibit at the island library, located in the community clubhouse, which also offers space for island events. Featured in the bottom photograph, the stork was used at baby showers, and the baker appeared at wedding receptions. Her charming drawings are found throughout Bessie Cammon's book *Island Memoir*. Jane is remembered for having beautiful handwriting, but she is even more known for her warm heart and generous spirit. (Top, courtesy of Anderson Island Community Club; bottom, courtesy of John Larsen.)

CHAPTER SIX

Musicians

It is hard to imagine a community devoid of music, and Anderson Island is no exception. Music has been produced here from the earliest times. Only a few names of musicians in the distant past are known, including Tony Larson, who played the accordion, and Sidor Johnson, the first church organist on the island. But there was music, and there was dancing. In *Island Memoir*, Bessie Cammon wrote, "local talent supplied the music. Violins and accordions were the popular instruments in general use, and I dare say those two were in most favorable demand; for even though the compositions may not have been . . . *perfect* at all times, nevertheless they kept perfect time—real swing music and it was harmonious."

Some islanders kept their musical gifts to themselves. Christine Anderson told the story of John F. Brolin, the otherwise sane and hard-working president of the cemetery association and school board member, who would at odd hours hear a tune in his head that would not go away. At that point, he would drop whatever he was doing and retreat into the woods, where he would play the melody on his silver flute until he was satisfied. Others, like the lovely singing Ostling sisters, would perform at all kinds of occasions to the delight of their hearers.

The annual Island Fair nearly always featured some form of musical entertainment. As rock 'n' roll, country, and folk music increased in popularity, the islanders staged dances and concerts with increasing frequency. The Johnson brothers, Walt and Tom, Seattle residents but islanders in the summer, began performing at the community clubhouse in the early 1960s and continue to rock the island to this day.

In the late 1990s, bands began to spring up all over the island. The Andersons, Not Quite Right, the Oro Bay Band, and Tripolar were on the leading edge of this movement. In recent years, numerous professional musicians have made the island their home, raising the bar to new heights and providing their audiences with year-round entertainment.

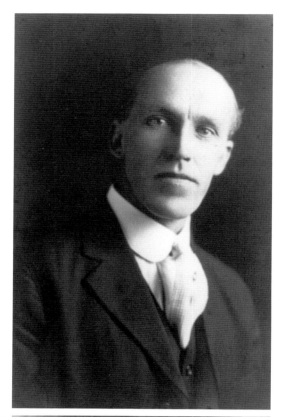

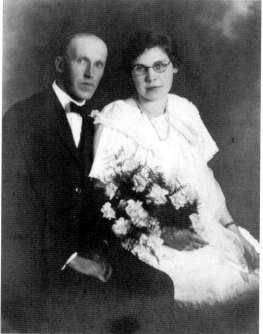

Sidor Johnson, Accomplished Organist
Sidor Johnson, son of Jonas Johnson, was the first organist who served Anderson Island. Given the proximity, it was decided by a committee representing both Anderson and McNeil Islands that the Sunne Church would be built on neighboring McNeil Island. Prior to that, Johnson had served the Swedish Lutheran Church of Tacoma. He was a gifted singer as well, singing bass in a quartet comprised of his brother Harry and Evangeline and Edna Ostling. He also played on the island baseball team, which, at that time, sprang up after the hay had been cut and baled, leaving a sizable mowed area on which to play. Johnson also served as postmaster beginning in 1909, a year after the island began to receive daily mail delivery by boat. After Sidor's untimely death, his wife, Gerda (shown with him at bottom), assumed the role of postmistress. (Both, courtesy of Cindy Ehricke Haugen.)

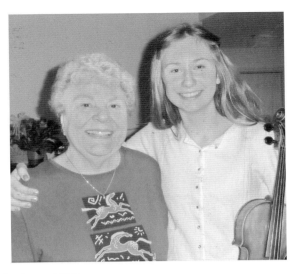

Dorothy Waltz, Music and Wings

Dorothy Waltz finally talked her parents into letting her take piano lessons at age seven. By the time she was 11, she was playing for the children's group at her church and sometimes for the evening service. Through her teen years, she played for hymn-sings every Sunday evening and for retreats all over Michigan. Waltz started organ lessons at 14 and began at the Detroit Conservatory of Music when she was 16. Throughout her life, her real love has been playing for church and accompanying singers. Moving to California later in life, Waltz took her children to watch the finish of the All-Women's Transcontinental Air Race and was smitten. Within two years, she had her private and commercial pilot's licenses and had logged many hours of acrobatics as well. She eventually flew in several transcontinental races and in the International Angel Derby. Her pilot wings went into space on the shuttle *Discovery* in 1998. Besides pursuing several parallel careers in business, Waltz has taught piano lessons on the island for many years, while playing the piano for church services, hymn-sings, and recitals, including with instrumentalists such as Talitha Anderson (shown above with her violin). Waltz's CD of personal favorites is a must-listen for music lovers. Dorothy and her husband, Bob Madden, are docents at the historical society and love to dress the part. One day, they playfully posed as "Island Gothic" in front of the Johnson farmhouse (below). Bob's hobby is designing and needle-pointing island and marine scenes. (Both, courtesy of Anderson Island Historical Society.)

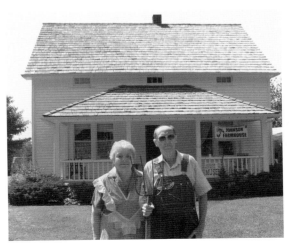

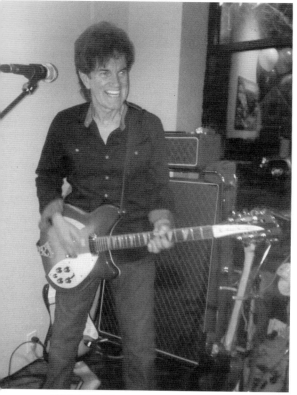

Walt Johnson, Lead Guitarist Extraordinaire

Walt Johnson and his brother Tom got to know Anderson Island while working summers for Rudy and Oscar Johnson and staying at their family place on Amsterdam Bay. Walt picked up his first guitar in Seattle when he was about six and started organizing bands with his friends in the fifth grade. He and Tom played their first gig at the Anderson Island Community clubhouse in the summer of 1963 and have been rocking the place ever since. After graduating from the University of Washington, Walt embarked on a full-time career, touring and recording with numerous bands, including the Sonics and the Machine. In recent years, Walt has raised the bar and the decibel meter by bringing his latest bands, No Rules and The 5 Johnsons, to the island. Walt is the inspired "Music CEO" of the annual Anderson Island Spring Concert, which features a diverse cast of island musicians playing pop music chosen to represent a specific theme each year. Pictured below from left to right are Walt Johnson, Tom Johnson, Bud Brown, and Bob Gordon. (Both, courtesy of Nancy Everley Johnson.)

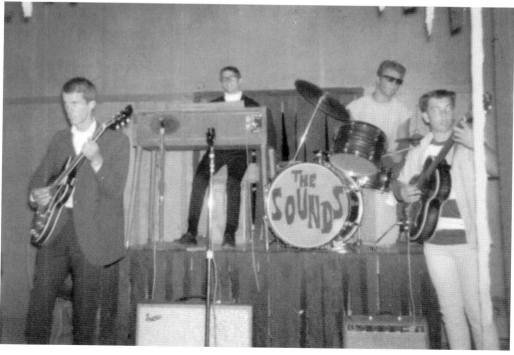

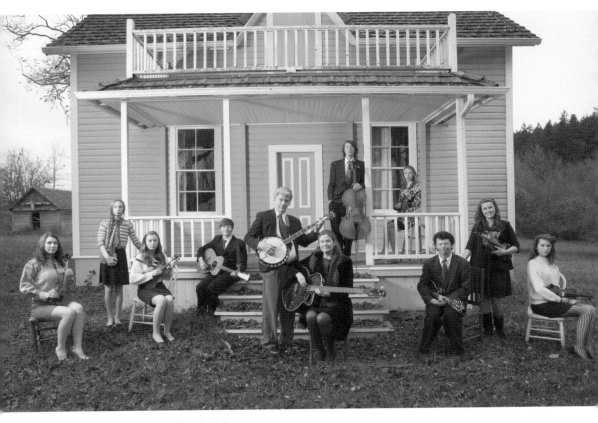

The Andersons, a Family Affair

Rick Anderson honed his musical skills singing folk songs on the beach in the 1950s and 1960s. He played at the Island Fair in 1975, the day he met his wife, Melissa. When children came along, they started the little ones on violin lessons by the time they were four, with piano lessons thrown in here and there. The children eventually branched out to other stringed instruments. Over the years, they have appeared in all kinds of musical events on the island, performing solo recitals, string quartets, bluegrass music, and playing in the orchestra for the island presentation of Handel's *Messiah*. Andreas plays occasional piano gigs at the Riv, while Jacob and Samuel are in the Seattle band Hey Marseilles, which has appeared on the island several times. Samuel also performs as the solo artist Arkomo, and Larissa is cutting an album of her own songs at Samuel's Seattle studio. Mary, Kristianna, and Rachel have all played in the Seattle Pacific University Orchestra, while Isabel and Talitha are always ready to perform in their string quartet at island functions. It is never quiet around their home! Shown here are, from left to right, Larissa, Talitha, Isabel, Jacob, Rick, Melissa, Samuel, Rachel, Andreas, Kristianna, and Mary. (Courtesy of Hayley Young.)

Not Quite Right

Jim Timmons and Bob Wilson, two musical doctors, got the idea of forming a band around 1999. Karen Wilson, Sam Grubb, and Rick Anderson were talked into joining them, and the result was Not Quite Right, as in "daft." The group met weekly at the Wilsons' home and polished their act enough to play at the Island Fair in the fall of 2000. Eventually, Carol Paschal, David Evans, and Paul Rogan joined the band, and they began playing bluegrass and pop music at various occasions around the island. Jim, Sam, and David eventually left the island, leaving the others to carry on until old age finally got the best of them around 2012. The band leaves behind a couple of CDs and echoes of their frequent appearances at spring concerts, memorial services, and the like. Pictured are, from left to right, (first row) Carol Paschal and Karen Wilson; (second row) Rick Anderson, Bob Wilson, and Paul Rogan. (Courtesy of Barton Dean.)

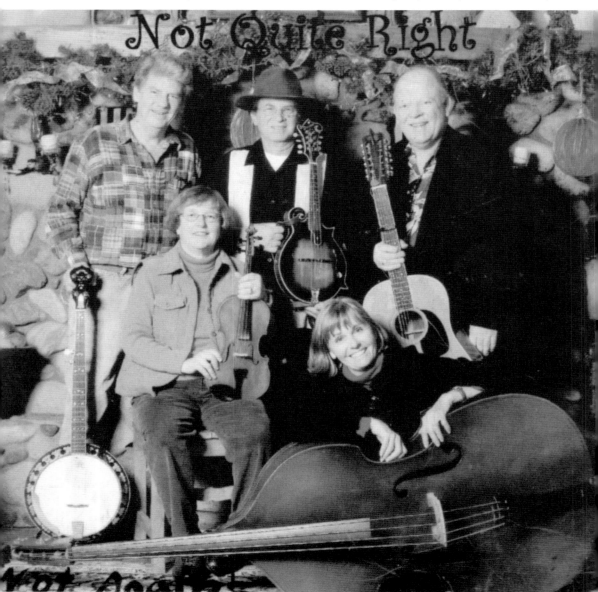

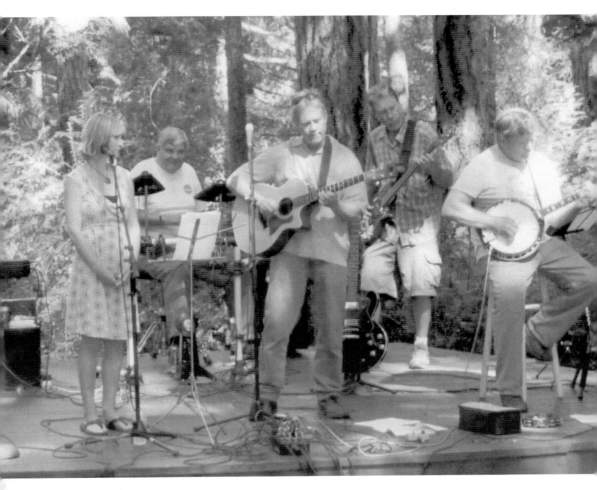

Oro Bay Band

When guitarist Paul Larsen and banjo-playing John Larsen decided to start a band in the late 1990s, they naturally recruited their brother Rit to play bass. They also signed up Roger Kohlwey to play mandolin. The Oro Bay Band grew to include, at one time or another, David Evans, Bob Wilson, Sandy and Krissa Sheppard, Jay Guenther, Rick Stockstad, Walt Melewski, Paul Smith, and Merilee Hawkins. They have played at virtually all of the major events on the island, including the Island Fair, the Salmon Bake, Farm Day, and the Apple Squeeze. The band also has monthly engagements at the Riv. Their music runs the gamut, from the Beatles to folk music, and always includes a generous serving of songs written by Paul, unfailing crowd pleasers. Their music video "Livin' in a Trailer" has taken its place among the classics of island culture. Pictured from left to right are Merilee Hawkins, Walt Melewski, Paul Larsen, Rit Larsen, and John Larsen. (Courtesy of Larry Clay.)

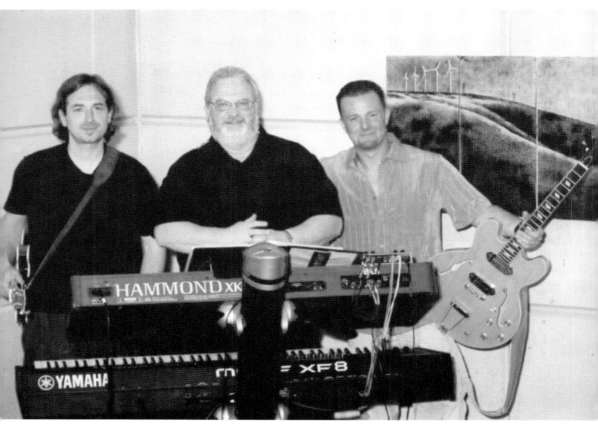

Tripolar , Island Jazz

Guitarist Andy Prisco (right) was playing weekly gigs at the Island Coffee Shop in 2006 when he met Chris Jupinka (left), another guitarist. Finding they had similar musical interests, they jammed together and decided to put together a set list of standards and get bookings wherever they could. A few years later, a pianist by the name of Mike Robbins (center) appeared on the island. After one rehearsal, Tripolar emerged. Playing a wide range of jazz favorites that showcased the members' musical virtuosity, the group appeared at a number of venues around the Northwest and, of course, performed annually at the Anderson Island Spring Concert. Tripolar disbanded in 2012, but their music lives on in the hearts of their fans and on bootleg DVDs. (Courtesy of Mike Robbins.)

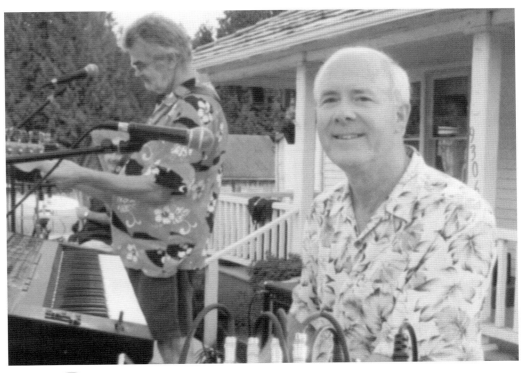

Rick Stockstad, the Piano Man

Rick Stockstad (above, right) grew up in Wenatchee and majored in music at the University of Puget Sound. He began performing in groups during the heyday of folk music and rock 'n' roll in the early 1960s. He also sang in concert choirs and acted in musicals. He was a founding member of Daryl and the Diptones, still going strong after 30 years, and has performed with Oro Bay Band as well as with the house band for the Anderson Island Spring Concert. A former private piano instructor, Stockstad also taught vocal and instrumental music to kindergarten through eighth grade, and recently retired as the music instructional facilitator for the Tacoma School District. He accompanies monthly sing-alongs at Narrows Glenn Senior Housing in Tacoma and is often heard playing the piano or his accordion (left) at island functions. (Above, courtesy of Rick Stockstad; left, courtesy Anderson Island Historical Society.)

Mike Robbins, the Geezer

Mike Robbins grew up in Seattle and attended Queen Anne High School. Starting piano lessons at age five, he formed his first rock 'n' roll band at age 13. He toured with numerous bands from the 1960s to the 1980s, including Marilee Rush and the Turnabouts and Pink Cadillac. He was the keyboardist for Sonny & Cher's West Coast tour and played keyboard on several hit recordings while attending the University of Washington. Later, he worked as a studio musician in Southern California and released four solo singles and an album of original songs, *Longtime Comin'*, for AVI Records. Meanwhile, Robbins earned a PhD in clinical psychology and began a career treating prison inmates, continuing to play as opportunities arose. Upon moving to the island, he immediately connected with other musicians and played in the jazz group Tripolar. Robbins has gained popularity in recent years with his series of Wheezin' with the Geezer concerts, sharing his vast repertoire of songs at events of all kinds and featuring other island musicians by invitation. In retirement, he maintains a private counseling practice and continues to pursue his passion for music, including recording his own original songs and participating in musical events whenever possible. (Courtesy of Mike Robbins.)

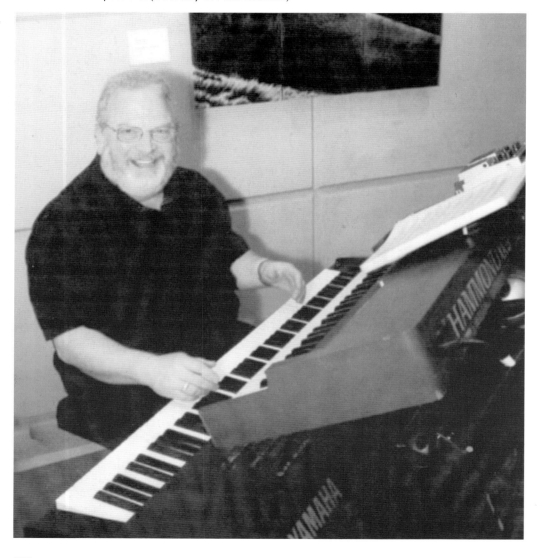

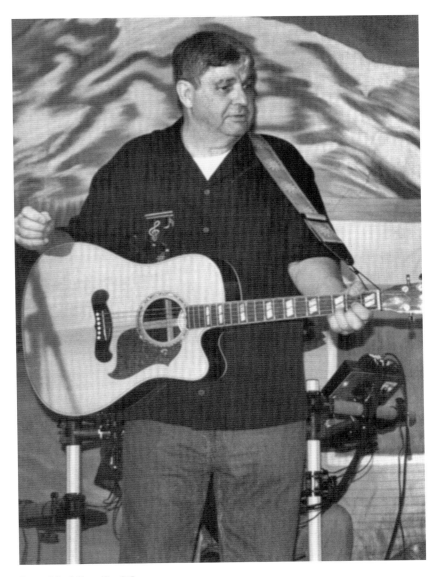

Walt Melewski, Alias Smith

Walt Melewski got the music bug from an uncle who was well known in their part of New England for his singing and guitar playing. When he was about 10, Melewski put down his accordion and started learning to pick. Elvis imitations came naturally to him. In high school in Mirada, California, he formed a band that played at dances and local shows. Moving to Anchorage, Alaska, he joined another band, which made a big hit with its authentic California sound. This led to his being recruited for the Gatormen, a group that toured the Northwest for several years. Later, he and his brothers bought a tavern in Black Diamond and provided the entertainment for many years. After selling the tavern, they continued to play shows in the surrounding area. Eventually adding a drummer, they became known as Alias Smith & Jones, gaining a following around Seattle over the years. Since moving to Anderson Island in 2000, Melewski has participated with Alias and connected with other island bands to play at the spring concerts, the Riv, and all kinds of island occasions. He has constructed a recording studio in his basement. With his vast rock 'n' roll repertoire, Melewski is a hit wherever he plays. (Courtesy of Larry Clay.)

Vivian Gordon Skagerberg, Time for Music
The daughter of John and Alice Johnson, Vivian Skagerberg grew up on the island and learned to play the piano as a young girl. On Saturday mornings, she would ride the ferry to the mainland and take the bus downtown to Tacoma's First Baptist Church for her lessons. When church services were held at Wide Awake Hollow, she would sometimes fill in at the piano. Later in life, her husband, Larry Gordon, bought her an organ, and when the Community Church was built, she became the regular organist for the congregation. Vivian has been the music director of Faith Independent Lutheran Church since its inception. For several years, she directed the Island Singers. She began singing with the Memory Singers in Tacoma in the late 1970s, and in recent years, has provided the piano accompaniment, as well. Besides her contributions to island music, Skagerberg has held virtually every office in the Anderson Island Community Club, of which she has been a lifelong member. She served as president of the historical society and, for many years, has directed the activities of the Anderson Island Cemetery Association. But, she still finds time for her music! (Courtesy of Vivian Gordon Skagerberg.)

CHAPTER SEVEN

Memorable Neighbors

Every community has its share of memorable neighbors, but, surely, islands can claim to have more than their fair share. Undoubtedly, the more remote and inaccessible the location, the more interesting the characters who choose to make it their home. From the famous to the obscure, Anderson Island, one of the less accessible of Puget Sound's many islands, has seen plenty of characters. Fortunately for the islanders, the interesting qualities that make their neighbors memorable seem to derive more from the likeable side of the spectrum than the notorious or dangerous, making for a generally cheerful community. Even Peter Sandberg, Anderson Island's answer to organized crime, enjoyed a certain esteem due to his generosity and good manners. The reader will have to look elsewhere to learn about the few unsavory types who tried to set down roots here. Recent years have seen an influx of refugees from the fast pace of urban life, drawn by the cozy sense of community, with characters varying from back-to-the-land hippies to full-time golfers and everything in between. Some love the island because of the perceived freedom from the limits imposed by organized society. Others appreciate the intimacy of small-town living, where it is a good thing that your neighbors know everything about you and stand ready to support you at all times. The pace and special challenges of living on Anderson Island have their way of weeding out those less suited for this kind of life. Folks agree, though, that being thrown together on an island is a sure antidote to the class differences and pretentiousness that are the bane of modern America. As one of the more popular bumper stickers proclaims, "We're all in the same boat!"

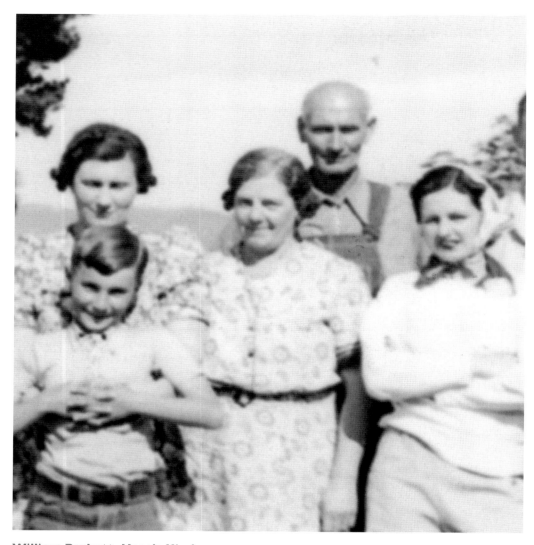

William Baskett, Here's Kindness

William Baskett (rhymes with "Marquette") brought his wife, Elsie, and three young daughters to Anderson Island in 1913. Originally Midwesterners, they had lived in Seattle and Bainbridge Island before signing on to work as caretakers at the C.B. Hopkins ranch near the site of present-day Interlaken. "Willie" and "Eda," as they were known to friends and family, found that the island suited them. A few years later, they bought Edward Ekenstam's homestead at Villa Beach. They eventually expanded their farm to over 100 acres, with Elsie taking their produce to Seattle to sell at the Pike Place Market once a week. William's niece Donna recently recalled the glorious summers the Basketts and their extended family enjoyed on Anderson Island. Elsie was admired for her lovely flower gardens and the mysterious perennial known only as "Mrs. Baskett's Flower." Later in life, William lived out his days in an apartment in one of the former poultry sheds of his farm, then owned by Earl and Hazel Heckman. Hazel wrote movingly of his courtly manners, his generous assistance with gardening chores, and the unforgettable toast as he raised his glass, "Here's Kindness!" Shown here are, from left to right, (first row) Dick Larsen; (second row) Hallie Baskett Larsen (Green), Elsie Baskett, and Donna Baskett; (third row) William Baskett. (Courtesy of Donna Baskett Gabriel.)

Dick Campanoli, Mr. Fix It

Dick Campanoli, affectionately known as "Campy," grew up in Tacoma and attended Stadium High School. From about age 12 on, he was fascinated with electronics and all things mechanical, and taught himself how to build and fix things by taking them apart and studying them. In his teens, he visited the island with friends and once stayed for three weeks. By the time he was 16, he was virtually supporting himself fixing electronics and appliances. His high school English teacher was also interested in electronics, so Campanoli tutored him in his spare time and got excellent grades in English, though he never turned in a single paper. For many years, he worked at various shops, did odd repair jobs, wired boats at a shipyard, and even put in a stint at Boeing. Through his friendship with Bob Reynolds, he moved to the island in the early 1970s. The life of a repairman on an island is never boring, and over the years, Campy has earned a reputation for being able to fix anything, anytime, especially televisions and stereos. Through his extensive connections in the salvage industry, he has the almost magical ability to come up with practically any kind of odd or rare part, and if he cannot find one, he will make one. (Top, courtesy of Dick Campanoli; bottom, courtesy of Lyder Leithaug.)

Steve Anderson, Showman

Steve Anderson grew up spending his summers at the family place on East Oro Bay. He graduated from Charles Wright Academy, where he excelled in sports, and established Northwest Soccer, an outlet for soccer equipment. He also worked as a welder at Concrete Tech before retiring to live full-time on Anderson Island. He became known as a person who could be depended upon in time of need, who dared to get up on a slippery roof, and who would provide firewood when someone's supply ran out. He also gained local fame for the spectacular fireworks displays he staged and for his elaborate holiday decorations. Anderson, who passed away in 2014, will forever be remembered as the man with the greatest known collection of agates, many gathered at night during low tides along the Oregon coast. (Courtesy of John Ullis.)

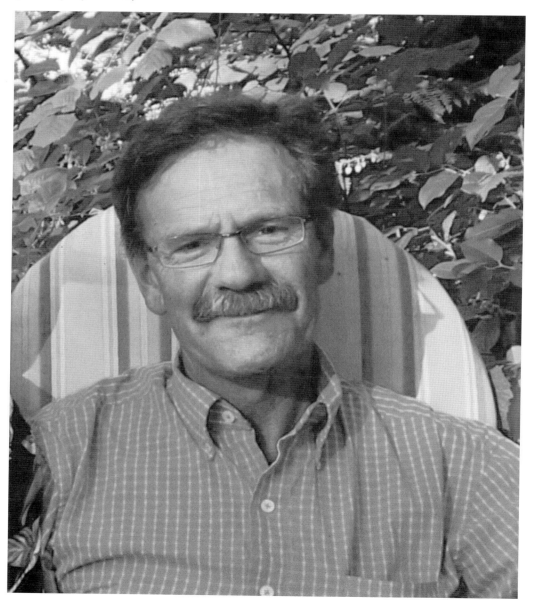

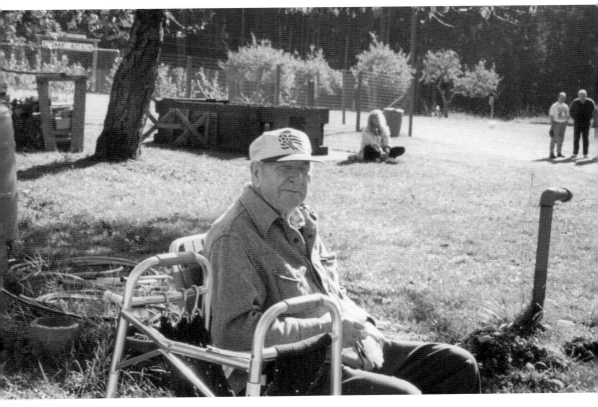

Ivill Kelbaugh's Grin and Kindly Manner

When Ivill Kelbaugh came to the island, he found work on Bill Baskett's farm as a farmhand. In time, he married an island girl, Pearl Anderson, and they raised a son and a daughter. During World War II, Kelbaugh proudly served in the Army Air Corps. He was a hard-working man of many trades. In addition to running their small farm, he worked for many years as a deckhand on the island ferries. A common sight around the island during the 1970s was Ivill's green station wagon, loaded with salal and huckleberry greens, which he picked and sold to florists in Tacoma. It was not unusual to find him working at island construction sites or hand-digging a well for a resident. Many still remember his knack for storytelling, his grin, and his kindly manner. (Courtesy of Anderson Island Historical Society.)

Ralph Philbrook, a Time for Peace
While looking around the Northwest for a peaceful place to relocate, Ralph Philbrook read *Island in the Sound* and decided to visit Anderson Island in the summer of 1972. Finding it to his liking, he made the acquaintance of Clarence Gulseth, who introduced him to Joe Proctor, who readily allowed Philbrook to stay on his property. For a while, Philbrook made his home in a remodeled house built by Gulseth and lived off the land, making ends meet by taking on odd jobs. Later, he boarded with Ivill Kelbaugh, a widower and retired brush picker. Always a keen observer of people and nature, Philbrook developed a deep affection for the island, for several years editing and publishing an island newspaper, *The Head*. Meanwhile, he has worked as a mechanic, taken care of the island parks, and done many kinds of outdoor work. One of his greatest accomplishments was blazing the trails around the Marine Park. Eventually, he built an elegant, three-story house of island-milled lumber, lavishly landscaped and decorated with flowers. For many years, Philbrook has studied and written on subjects related to global peace and world history, and recently made his debut on the Internet with his blog worldfamilycooperative.org. (Courtesy of Ralph Philbrook.)

Clarence Gulseth, Mr. Sociable

One of the friendliest people to ever live on Anderson Island was Clarence Gulseth. In fact, some islanders found him a little too friendly, as his unannounced visits often occurred at odd hours—Gulseth could not imagine anyone not being glad to see him. He was born on McNeil Island and grew up and attended school on Anderson Island. He served the US Army for the duration of World War II and spent most of his adult life helping his parents farm and working on tugboats. In his retirement years, before he moved to the Old Soldiers Home in Buckley, he roamed the island in his battered blue pickup truck, keeping up a spirited conversation with himself and looking for company. (Both, courtesy of Anderson Island Historical Society.)

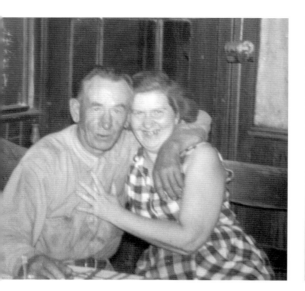 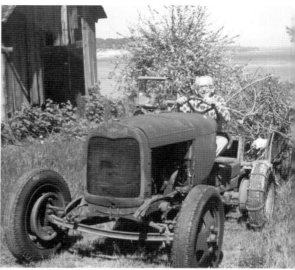

Rupert Burg, First Island Welcome

Rupert Burg was just three months old when his parents moved to Anderson Island. Like most island families, they worked very hard to survive. They grew enough in their gardens, raised cattle for meat and milk cows for milk, and often had a goat to help keep the brush down and, usually, a flock of chickens. Burg would continue this way of life. He pursued several lines of work throughout adulthood. Toward the end of World War I, he worked for the Todd Shipyard Company in Tacoma, and later as a deckhand on the island ferry. He was a talented tile mason; today, at least one island home displays his tile work. Burg also did some logging work for islanders. He was 42 years old when he and Melba Parr (left) were married in 1938. Making up for lost time, they raised seven children. The Burg property is located next to the ferry dock. When the kids were young, they often greeted visitors, smiling and waving hello as cars disembarked the ferry. Today, several family members live on the island, and others visit often. Few knew that Rupert Burg was also a gifted artist. He loved drawing landscapes; many pieces hung from the walls of their home on Villa Beach. In 1984, tragedy struck the family when the Burg home burned to the ground and Rupert lost his life. (Both, courtesy of Anderson Island Historical Society.)

Lyle Carlson, Anderson Island's Valentine

Lyle Carlson's middle name was Valentine, since he was born on that special day in 1921. It should also be pointed out that the name Lyle means "of the isle," so he was especially aptly named. He grew up on the island and took over the Carlson family store on Oro Bay after his parents retired. With his impish grin and droll sense of humor, Carlson was an island institution, loved and appreciated in the community. His one-room store held just about anything a person could need on an island, and customers knew that prices would hold firm until inventory was off the shelves. For years, islanders depended on him making his Thursday run to town for fresh supplies. Upon his return, the neighborhood boys would help him and his brother Gene (above right) unload the truck, and could always count on receiving a nice big candy bar afterward. Carlson had no use for daylight saving time. A hand-printed sign underneath the clock on his wall proclaimed "Standard Time" all year. (Both, courtesy of Anderson Island Historical Society.)

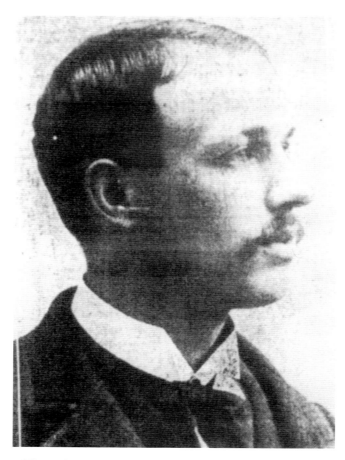

Peter Sandberg, King of Fourteenth Street

Peter Sandberg, born in Sweden, came to Tacoma in 1889 and rose from rags to riches in no time. Starting out as a carpenter and construction worker, he entered the hotel and liquor businesses, became active in politics, and built the first "skyscraper" in the Northwest, the famous Sandberg Building on Tacoma's Pacific Avenue. Sandberg was highly thought of by his fellow Swedes, as evidenced by the enthusiastic entry about him in Ernst Skarstedt's *Swedes of Washington* (1908). To wit, Sandberg's wealth was estimated at over $1 million. He owned "one of the largest automobiles in the state, one of the fastest powerboats on Puget Sound, and an impressive home on North Tacoma Avenue." Other reports about him and his activities were not so glowing, but these can be overlooked, as Tacoma was young and booming. In the early 1900s, Sandberg owned around 300 acres on the northwest side of the island, upon which he established a farm, tended by a foreman and a crew of laborers, mainly drawn from his Tacoma customers. Bessie Cammon wrote colorfully about the derelicts who disembarked at Johnson's Landing and set out on foot to Sandberg's "Poor Farm." Many young island boys found work at the farm during their teens. Whatever others may have thought of the "Saloon King," these boys found him to be kind and generous. Many of his contemporaries asserted that his word was as good as gold, and he was said to be an easy touch for anyone with a hard-luck story. Alas for Sandberg, who had guaranteed the loans of many of his bankrupt friends, Prohibition and the Depression got the best of him. As the headline for his obituary in the *Tacoma Daily Ledger* stated on April 22, 1931, "Peter Sandberg, once wealthy King of 14th Street, dies destitute." At least the island has Sandberg Road to remember him by, and perhaps the odd whiskey flask picked up on the side of the road by the grandparents of some of today's old-timers, back in the days when Sandberg ruled. (Courtesy of Anderson Island Historical Society.)

Volunteer Island Patrol

The Anderson Island Crime Task Force, now known as the Volunteer Island Patrol (VIP), was established in 2003 to reduce crime on the island. The VIP provides a number of safety- and security-related services to the community, such as unoccupied house and property checks for unauthorized entry and storm damage; random watch patrols of neighborhoods, parks, and island facilities; and traffic and parking control for island events and holiday and summer ferry lines. An additional service is the investigation of islander concerns about suspicious activities, such as trespassing, poaching, illegal dumping, and abandoned vehicles. The VIP board members take turns in manning a 24-hour phone line for non-emergency calls. Shown here are, from left to right, Rich Sullivan, Jerry Bausman, Leslie Lamb, Kendel Lyman, Sarah Garmire, Dave Jacobsen, and Bobbi Sullivan.

The Pierce County Sheriff's Department provides the VIP with training, two patrol vehicles, and partial funding for maintenance, equipment, and operations. They also provide funding for some sheriff's deputy overnight/overtime patrols on busy holiday weekends when requested by the VIP board. In addition, VIP receives generous donations from appreciative community members and organizations in support of its ongoing efforts. (Courtesy of Dave Jacobsen.)

Mary Jane Reynolds, Jane of All Trades

Mary Jane Reynolds joked that she has held every job on the island. It may be true. Among her roles were serving as waitress at the restaurant, management, helping with establishment of the fire department, and volunteering for and hosting every island organization. Her nickname, "Rowdy Red," refers to her energy level. Her husband, Mike, was the island lineman for Tanner Electric. Before there were cell phones, Mary Jane (left) was the go-to person for news about outages, and she went out in every kind of weather to take messages to Mike (below). (Left, courtesy of Melissa Anderson; below, courtesy of Terry Bibby.)

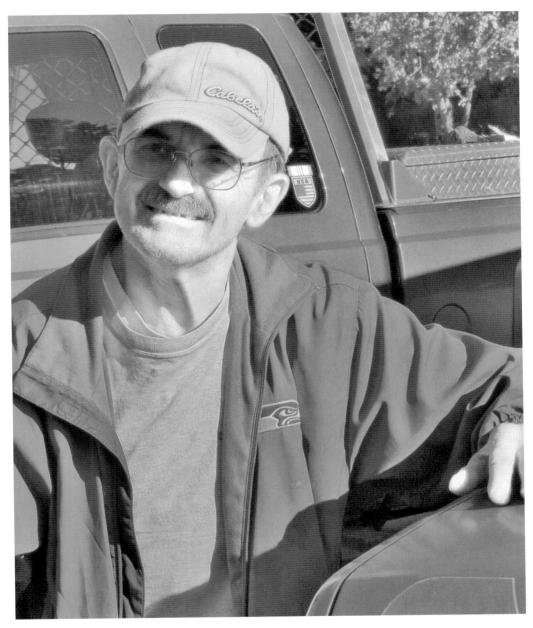

Gary Wood, Tough as Nails
Born in Lebanon, Oregon, Gary Wood attended Warner Pacific College before moving to Tennessee, where he worked for a hospital supply company. Back in the Northwest, he worked at several mills and then lived off the land in Idaho for a spell before landing on Anderson Island in 1979. Wood worked as a carpenter for White's for 11 years, following which he managed the Anderson Island dump for 19 years. He and his wife, Vera, delivered the *Tacoma News Tribune* from 1987 to 2008. In 1986, Wood was diagnosed with MS and has battled the illness gamely from the start. His staunch determination to be a contributor in every situation has earned him the admiration and respect of his fellow islanders, who consider him a great role model. (Courtesy of John Larsen.)

Hank Hollenbaugh, for All Seasons
Hank Hollenbaugh spent his youth in Pennsylvania, joining the US Air Force as soon as he was old enough. His military career brought him to the Northwest, where he and his wife, Faye Lynn, discovered Anderson Island and made it their home from 1970 to 1972. They eventually moved to Juarez, Mexico, for eight years, managing an orphanage and building medical and dental clinics. Back on the island in 1991, Hollenbaugh worked for the Island General Store for 17 years before retiring. The joy of his life in recent years has been helping people in need. He operates a food bank, donates firewood to his fellow islanders, and cheerfully makes himself available to solve other peoples' problems. His current specialty: repairing discarded Christmas lights and distributing them to brighten the holidays. (Courtesy of Hank Hollenbaugh.)

Pete James and the Glass Anchor

Pete James and his family were island residents for many years, during which time he served as a deckhand on both the *Tahoma* and the *Pioneer* ferries. The first ferry left the island at 7:00 a.m., so in winter, James took time to stop by the school and build a fire to ensure that it was warm for the schoolmarm and students when they arrived. In the early 1950s, he served on the school board. Ferry regulations were nothing like they are today, and anyone was allowed to climb up the ladder to the pilothouse. Many island kids were trained as future ferry captains, zigging and zagging across the bay. Stories are still told about Pete's friends being invited down to the engine room to view his "glass anchor." It will never be known for sure, but rumor has it that his glass anchor was nothing more than a bottle of whiskey. (Courtesy of Anderson Island Historical Society.)

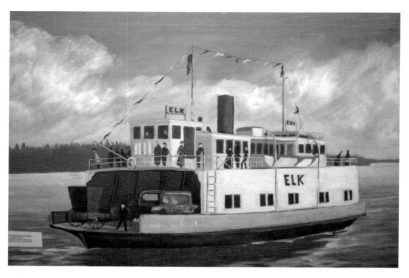

The Ferry Crew

In earlier days, with smaller ferries and fewer runs, there were unwritten rules, such as not passing other cars en route to the ferry. No one saw anything wrong with throwing garbage overboard in that enormous body of water called Puget Sound. After performing their required duties, the deckhands often conversed with passengers as though sitting in the barber's chair. If a driver was coming down the loading lanes while the gate was about to close, a blink of headlights was enough to get the deckhands to hold the gate until the car could board. Hollywood crews filming movies such as *Three Fugitives* and *War Games* provided stories to be shared with those who commuted and had missed the action. The captain and crew went the second-mile in their efforts to help. Currently, with the 54-car ferry, deckhands maintain military precision while still meeting the public's needs. If the ferry is a little late, it may be because the crew rescued an endangered kayaker or paused for a family to spread the ashes of a loved one. (Above, courtesy of Anderson Island Historical Society; below, courtesy of Mike Iha.)

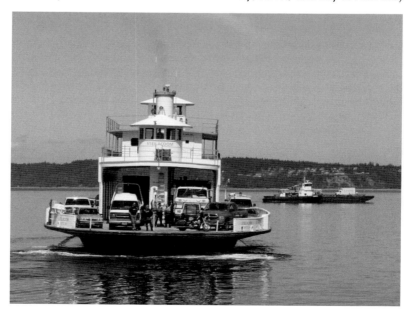

American Legion, Community Outreach

Anderson Island is located near Joint Base Lewis-McChord and is home to many active and retired military people, so an American Legion post was welcomed. Named for one of the island's highly decorated veterans, the Ralph L. Barsanti Memorial Post No. 265 received its charter in 2012. It welcomes eligible veterans from all branches of the armed forces.

The American Legion has become very active and extremely giving to the local community. It has supported Anderson Island's School Booster Club, historical society, community club, Young Life, Volunteer Island Patrol, and park and recreation district. It has purchased supplies for local schoolchildren and donated food and money to the Island Food Bank, using funds raised from the weekly bingo games. Most important and per its charter, the Legion is a tremendous support for the island's military veterans and their families. Pictured here from left to right are Billy Meints, Charley Duncan, Chuck Limeberry, and Lee Schauf. (Courtesy of Anderson Island Historical Society.)

Quilts of Valor, Honoring Veterans

Karen Vickers (second from right) accepted this quilt, made for her mother, Marge Johnson. It was presented by Barb Knudson (left) and Sandi Skewis (far right). The Anderson Island Quilts of Valor is affiliated with the national foundation and has joined more than 10,000 quilters to honor veterans and servicemen. Since it began in July 2013, the Anderson Island group has made more than 40 quilts. The quilts honor island veterans, family members, and homeless veterans. These beautiful, comforting quilts, meant to be used, warmly thank veterans for their service to the country. (Courtesy of Barbara Knudson.)

Simon Westby, Marine Mailman

Mail "delivery" evolved from people having to row or sail to pick up their mail in a town on the mainland to having island post offices, sometimes one, sometimes two, with an unpaid postmaster/postmistress. Daily mail came to the island in 1908, with mail carried via rowboat by islanders such as Matt Iverson and August Burg. Iverson did use his sailboat when weather allowed, but storms cannot always be predicted. During one delivery, his mast broke in heavy winds. Iverson got soaked, but he saved the boat, and the mail arrived in its pouch without damage. By motor, Glen Elder carried mail for many years. In 1934, T.W. Peterson had the contract; he was succeeded by Danish-Norwegian Maurice Milgard in 1938. He traveled to the island in a 26-foot Libby McNeil boat that resembled the craft seen in the movie *African Queen*.

Norwegian Simon Westby was delivering mail to Anderson Island in his 32-foot, 14-horsepower boat from Steilacoom on November 7, 1940. On that day, a fierce storm with winds over 40 miles per hour destroyed the Narrows Bridge, which is located just a few miles north of Anderson Island!

Island mailmen were friends as well as heroes. All who use handheld electronic devices today can relate to the joy of receiving daily mail when it became available on the island. (Courtesy of Cindy Ehricke Haugen.)

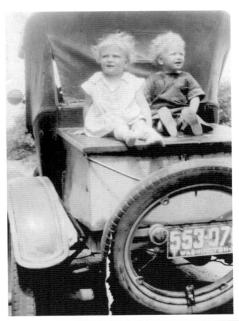

Bob Wagnild, the Collector

Bob Wagnild and his sister Marilyn Brown (left) had an early start with automobiles! Growing up in Tacoma, Bob visited the island often with friends who had relatives living there. After graduating from Stadium High School and the University of Washington, where he was in ROTC, Bob was all set to accept a job on Alcatraz when the US Army called him to active duty. He served in Korea and rose to the rank of lieutenant colonel in the military police. Afterward, he went to work for the State of Washington as a liquor inspector, a job that took him all over the Northwest (mostly undercover). One fringe benefit of his job was that he got to see just about every abandoned car in the state. As his brother-in-law puts it, "Bob never saw a piece of junk that didn't have potential." Fortunately for the island, some of Bob's vehicles are now safely in the possession of the Anderson Island Historical Society. (Left, courtesy of Marilyn Wagnild Brown; below, courtesy of Anderson Island Historical Society.)

Volunteers, Anderson Island Historical Society

The authors have designated that their share of royalties from sales of this book go directly to the Anderson Island Historical Society. AIHS volunteers do restoration, repairs, and maintenance of the museum's collection of artifacts and 15 historic buildings. The society's goal is to ensure that future generations may learn about their rich island heritage. Shown here are, from left to right, (kneeling) Sarah Garmire and Jane Groppenberger; (standing) Kathy Guild, Glenn Robb, Carol Duncan, Dick Throm, Carol Paschal, Jeanne McGoldrick, Brenda Gamble, Ed Stephenson, Lucy Stephenson, and Todd Billett. (Courtesy of Anderson Island Historical Society.)

Quilters, Maintaining Island Tradition

From Lois Scholl to Bettymae Anderson, then to Bernice Hundis, the mantle has been passed to head up the historical society's Lois Scholl Society. Highly skilled quilters abound on the island. They participate in the annual design and making of a quilt that is raffled off to help support the Community Club and in the quilt display during the annual Salmon Bake. Bernice Hundis is the go-to person for preservation and restoration of fabric or paper in the museum collection. She has a magic needle, enabling her to fix anything. Shown here are, from left to right, Andrea VanOutryve, Catherine Owens, Lorrie McLean, Barbara Hummel, Catherine Spears, Bernice Hundis, Cathy Thome, Marge Luther, and Sandi Skewis. (Courtesy of Anderson Island Historical Society.)

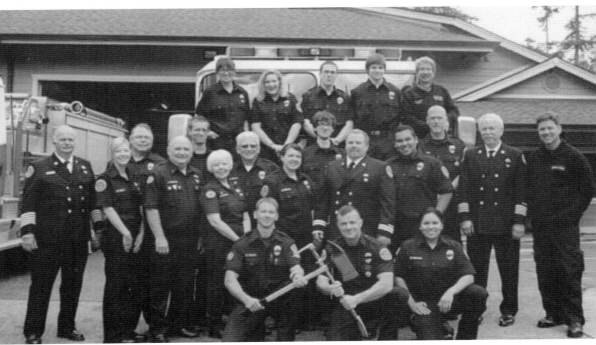

Pierce County Fire District No. 27

In former times, residents of the island rushed to extinguish neighbors' home fires. When telephones came to the island, one long ring drew them to the phone to learn the location of a blaze, where they again rushed to help. Mary Jane Reynolds told how the lack of medical assistance was the incentive to getting a petition signed by residents. She and Judy Adams once went to Auburn to pick up a "beater" Cadillac ambulance. It barely made it to the island and was in constant need of repairs. One day, Morris Krepky called Reynolds and said, "All right, we're planning!" and, over a cup of coffee with Jim Morrison, the three crusaders decided to rally support and apply to the county for funding to establish a fire district. They were awarded $360,000, receiving it in $1,000 warrants that had to be signed by Reynolds and Morrison. By the time the 360th warrant was signed, the treasurer of Pierce County told them that he could not even read their signatures! From that beginning, they acquired land, a design, vehicles, equipment—most of it donated, hand-me-downs, or bought for pennies on the dollar. Morris had resources, as well as knowledge and vision for what had to be done, and when.

Another benefit of the fire district, besides the fire and rescue protection, is that many young islanders have become professional firefighters and/or EMTs as a result of their training on the island. The first building was dedicated in 1981. Morris Krepky served as fire chief from 1978 to 1982. Currently, Anderson Island has a fireboat, which has rescued people from drowning, saved watercraft from fires, and transported seriously ill islanders to the mainland for advanced medical assistance when recommended by the EMTs. (Courtesy of Anderson Island Fire and Rescue.)

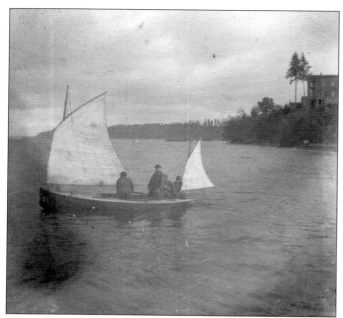

Sailing, Sailing

The earliest European settlers of the island were predominantly Swedes, Danes, and Norwegians. Many of them came from the coastal regions of those countries and were very much at home living close to the water. They naturally brought the techniques they were accustomed to and put them to good use while living on an island. Here, Matt Iverson and Erik Halverson pilot their boat across Puget Sound. (Courtesy of Anderson Island Historical Society.)

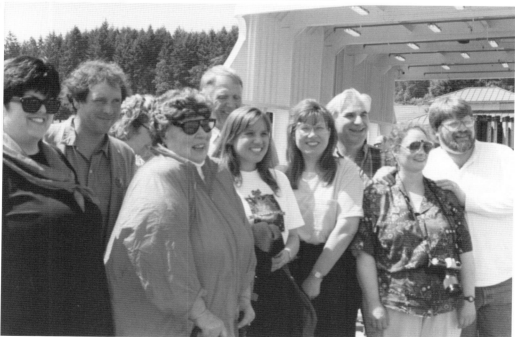

Sailing Puget Sound Today

Members of the Erik Anderson family enjoy the first official voyage across the sound on the *Christine Anderson*, honoring her legacy of hard work and community. Pictured here are, from left to right, Nancy Anderson, Eric Anderson, Erin Anderson, Bettymae Anderson, Randy Anderson, Heidi Robinson, Clara Robinson, Gary Robinson, Deborah Anderson, and Mark Lyon. (Courtesy of Anderson Island Historical Society.)

INDEX

AN IMPRINT OF ARCADIA PUBLISHING

Find more books like this at
www.legendarylocals.com

Discover more local and regional history books at
www.arcadiapublishing.com